SECOND STORIES

Conversations with Women
Whose Artistic Careers Began
After Thirty-Five

GLORIA FRYM

With Photographic Portraits by Debra Heimerdinger

CHRONICLE BOOKS/SAN FRANCISCO
Published in Association with Robert Briggs

Acknowledgements:

to Alameda County Neighborhood Arts Program, Oakland, California,
 for a year of grace,
to Diana Coleman, Robert Briggs, Debra Heimerdinger for their faith,
to the many artists interviewed though not included in this book,
 my deepest thanks for sharing your lives with me.

Note on the illustrations:

Photographs of Helane Aylon, Beatrice Berlin, Josephine Carson, Bella Feldman,
 Bobbie Louise Hawkins, Cherry Jackson, Frances Jaffer, Eleanor Lawrence,
 Terry Sendgraff, and Gloria Frym by Debra Heimerdinger.
Photograph of Malvina Reynolds by Diana Coleman.

Library of Congress Cataloging in Publication Data

Frym, Gloria.
 Second stories.

 CONTENTS: Helane Aylon, painter.— Beatrice
Berlin, printmaker. — Bella Feldman, sculptor.
— Bobbie Louise Hawkins, writer. [etc.]
 1. Arts, American. 2. Arts, Modern—20th
century—United States 3. Women artists—
United States—Biography. I. Title.
N504.F79 700'.92'2 [B] 79-9390
ISBN 0-87701-152-4

Composition by Hansen and Associates.

Chronicle Books
870 Market Street
San Francisco, CA 94102

TABLE OF CONTENTS

[handwritten inscription] 1-28-81 For my dear good friend, Jane — on your 35th Birthday — I'm so glad to know you & to be your friend May your warmth & beauty that is yourself with each & may you receive same Jay & Caroline

Into the world of continuance, to find
I-who-I-am-again, who wanted
to enter a life not mine,
 to leap a wide, deep swift river.

At the edge, I stand. No, I am moving away,
walking away from the unbridged rush of waters towards
'Imagination's holy forest,' meaning to thread its ways,
 that are dark,
and come to my own clearing.

Denise Levertov,
"Relearning the Alphabet"

INTRODUCTION

This is a book about Yes. It is a collection of yeses which were once maybes, intersected by versions of no: I can't, I don't know how, I shouldn't, I'm afraid, they won't let me. It is a book informed by the notion that people can and do transform their lives after carrying around a particular obsession for many years without fully actualizing it.

Second Stories is a book that documents how Yes became a complex priority in the lives of ten artists. It is a book about the gap between the will to create and the creation. It is also an inquiry into the personal and social conditions in which these artists came to produce art. It is furthermore a collection of personal reconciliations with what might once have been a contradiction in terms for each artist: being a woman and being an artist. It is not a book of art criticism, but a means to comprehend art made by women, women artists *as* women, and women as professional artists.

"Artists," says writer Bobbie Louise Hawkins, "create themselves out of themselves." In this act of necessary cannibalism, what makes people transform themselves into artists? What wells in their personal histories do they tap into in order to produce works that have universal meaning? How do they make their art? How does the making of their art affect their intimate relationships with others? How are courage and will gathered and applied to desire?

7

It was my intent to make stories visible that might otherwise have remained invisible. I have chosen the interview format because I wanted the artists to speak for themselves, with my questions as catalysts. I sought to provide a personal and subjective approach with minimum interference from me, as a writer, so that the reader could dip into the life of each artist as I did during the interviews. In an effort to present each artist without glamorous obfuscation, I saw myself as a conduit of information. The mystique of the artist is an issue that I feel has important implications for women in particular, whose work has long been invisible or unrecognized or not seriously considered.

I approach the issues raised in *Second Stories* as an artist and a feminist. During a decade of popular usage, the term "feminism" has become loaded with controversial and confusing connotations. The term "feminist" is perhaps as misunderstood as the term "Jew," at once full of cultural pride and historical shame. While for some readers "feminism" may imply a fixed ideology or monolithic doctrine, I understand and use the term and its derivations as a way of thinking about the conditions of human life, as a point of view, as a broad and flexible philosophical base. For me, feminism is a dedication to female expression and activity, especially expression that historically has never been explored or formally recognized. From this perspective, feminism also seeks to investigate new forms of expression and activity generated, influenced, and realized by women, for the benefit of all humanity. Such a point of view enables me to question the assumptions of history in general and aesthetics in particular. However, I am not a journalist or a sociologist, so I draw no conclusions about the specific phenomenon of women becoming serious about their art later in life. I simply continue to ask questions, and to pose more questions to the responses the artists have offered. I hope that both the questions and the responses will provoke further query.

I began this inquiry when I was thirty years old, at roughly the time when I began to take my own art seriously. I was new to northern California, without academic connections, fairly isolated, unemployed, and very curious about how other artists

were doing what they do. I met a painter who told me the remarkable story of how she came to make art. She joked that she was a "late bloomer." I was pretty sure there were other late blooming artists and I proposed that the Alameda County Neighborhood Arts Program in Oakland hire me as a CETA writer to find out. They asked me, "What immediate social value does such a project have for the community?" I told them, "Inspiration and a lineage to stand on, the lineage women have either never had or never known was available to them. Besides," I said, "I am trying to make *myself* into an artist. I need examples. I intend to make a book out of my idea whether or not you hire me." They hired me.

When I generated publicity for the project, I received hundreds of responses from women all over the country, making all kinds of art. But I was looking for what I considered *serious* artists: women who had made a solid commitment to their art as a way of life, producing steadily, willing to make the necessary emotional and financial sacrifices to feed an obsession. I knew what I meant by serious and so did the women I ultimately interviewed. I suppose, in some respect, I was trying to validate my own commitment.

In the course of two years, I interviewed several artists who could not be included in the final collection. Their lives and work are every bit as courageous as the artists I finally chose. In some cases, my choices were based on the quality and development of the work. In all cases, I chose women whose work has the value of art to others in their professional community and whose stories were unique to me.

Some lucky people receive divine callings at an early age and heed them. Some never heed them. And some choose much later to hear the callings and take deliberate action. These are the women of *Second Stories*. All of them share two unusual qualities: When they were in their twenties, their lives were radically different from the lives they lead now; and they hit their artistic strides later in life than most professionals. In some cases, their lives as artists bloomed long after they were thirty-

five, as with singer Malvina Reynolds, who was fifty-seven when she sold her first song, "Turn Around" (ironically a tune about time and aging).

Flamboyant success stories of women who made it to the top overnight are all very thrilling. Women such as Louise Nevelson and Georgia O'Keefe, who both knew they wanted to be artists by the time they were ten years old, are heroic figures, to be sure. But what about the ones who were slower, who, for one reason or another, thrashed for decades before they took themselves seriously? What about the ones for whom the memory of indecision, inhibition, and battle was still raw enough to be fresh? What did they go through that I wouldn't? What did they face that I might?

A lot, on both counts. For one, they contended with obstacles that are somewhat different for my generation. During a conversation with novelist Josephine Carson, I discovered that all of the women I'd interviewed, with the exception of playwright Cherry Jackson, were born before or during the Depression. How did this fact of their growing up in a world that had come to a halt affect their latent emergence as artists? It is surely valid to say that for most women of the several generations included in this book, expectations were different. Formal education, for some, was curtailed or postponed because of financial incapacity. To emerge as an artist from the particular political and social climate of the 1930s and 1940s must have required great tenacity, considering the severe material disadvantages of the era.

Those who bloomed before the renaissance of the women's movement became artists in spite of or perhaps because of immense pressures that, for the most part, discouraged them. What I glean from these stories is the twentieth century female counterpart to the nineteenth century male-dominated rugged individualism, with the artist as the solitary pioneer striking out into the territory of the unknown, breaking, this time as woman, away from the psychological holds of the nineteenth century.

With the exception of photographer Eleanor Lawrence and her late sister Malvina Reynolds, all of the women in *Second*

Stories were born elsewhere and eventually located in California. This phenomenon also seems to me to be part of the tradition of the pioneer urge westward. Were they unconsciously breaking with Eastern tradition and its established art milieux and conventions? Does the West provide a less patriarchal, less structured atmosphere for burgeoning artists?

This issue of location raised even further questions. Are there women artists in their middle years just emerging in Dubuque, Iowa? If so, will they stay there? Can they make art and become successful without the support of others like them? "Can you imagine me in Tulsa, Oklahoma, in the 1930s and 1940s," asks novelist Josephine Carson, "trying to take myself seriously as an artist? Anybody with any variation on the local bourgeois themes, anybody with any creativity really tried to get out of that town." Does this mean that an emerging artist might do better to live in or near one of the major urban centers of this country, with some proximity to others who are trying to make art? These issues were pondered, and remain unanswered. I am certain, however, that I could have made the same inquiry in New York City and found many late bloomers. I am not so sure I could have conducted this project in a small town, though.

Regardless of where these women came from and where they now live, I believe they provide us with certain prototypes of personal transformation. They are presented at various stages of artistic development. None of them is, by economic standards, a smashing commercial success. Some support themselves by their art; others do not. But as critic John Leonard tells us, perhaps a hundred writers in the entire country ever make a living strictly from their books. Good artists, even great artists, rarely make money by their art alone, nor are they well known outside their own milieu. In any other profession, one is expected to climb the ladder of success. As most professionals grow more competent, they are socially acknowledged and remunerated by salary increments and promotions, because the standards of excellence and progress are, for the most part, established. For artists, this is not quite the case; time is never a

linear scale measured by wage increases and promotions. In fact, there is no guarantee that after a major show or performance or publication an artist will make a penny from what may be outstanding and innovative work. The "rewards" are internal. And all artists have second stories in this respect, because they must plunge right back into the well of their own history for the raw material of their art. The struggle is continuous and lifelong. It is a digging deeper and deeper into the source and into their personal chaos that makes artists who they are, and ultimately influences the progress of their work.

Given the liabilities and insecurities of the life of an artist, it is no wonder that these women spent years resolving conscious and unconscious ambivalences towards the seriousness of their intentions. Some were busy fulfilling prescribed "feminine" duties and emotional expectations that often discouraged or obscured creative possibilities for them. "I started an occasional painting at home," recalls printmaker Beatrice Berlin, "and got opposition from my first husband, who didn't like me to get serious about it." "I held myself back," says sculptor Bella Feldman. "I didn't understand the kind of intensity, the kind of total focus that a serious artist gives to work." "You know," muses playwright Cherry Jackson, "there are parts of you that don't grow unless you get what you need. . . . I mean, the grass doesn't grow until the rain comes."

If making art calls for single-mindedness, it also requires a kind of disobedience, a certain self-abandon and self-generating permission, attitudes that have never been socially validated for artists in general and women in particular. Although the women's movement of the 1960s and 1970s cannot be called responsible for encouraging the emergence of these artists, it may be safe to assume that feminism has, in fact, helped to create a condition of possibility and cultural receptiveness for them and for women of my generation. This has something to do with psychological, if not material, support systems which have encouraged women to throw out the old prescriptions and create the concepts of their once-thwarted desires.

When I found them, none of the artists of *Second Stories* were

novices, and some were relatively well known in their respective fields. But how did they get there? At what point did they make their choices? All described a gradual unfolding, years of semi-conscious knowing and years of conscious wrestling with the knowledge that what they wanted to do was make art. None received instant revelation. What were the turning points for them?

All of these artists were doing something else before they began to take their work seriously. Some did not make art at all —playwright Cherry Jackson was a physical education coach for ten years. Some were involved in a different art than when I interviewed them—Malvina Reynolds wrote novels before she turned to singing; writer Bobbie Louise Hawkins had a solo exhibit of her paintings and collages when she was forty years old. Others interrupted their art with long, non-working silences —photographer Eleanor Lawrence sold photographic equipment and worked in commercial darkrooms for twenty years; printmaker Beatrice Berlin was first a painter, then a dress designer, and began to make prints in her mid-forties. All of these artists had to break from one life to lead another. When and how did they realize the depth of their commitment to art? The death of a family member, a severe illness, a battle for a job, the struggle for recognition from another artist, the acquisition of a working space, ostracism by a political group—all were battles that contributed to the necessary confirmation. Each story is different, none is self-congratulating, all are resolutely intrepid.

During the course of these interviews, the artists talk about the psychological, educational, and financial problems they had as women working in art. They talk about when the amateur in them faded and the professional took hold. They talk about how they managed to juggle domestic responsibilities, intimacy, and nurturing with their art. They speak of the need for lineage, mentors, and models. Some are feminists, others are not. Some are struggling in the vanguards of their fields and do not identify with a current school or group. Some discuss their alienation from the avant-garde; some have made a working world of their

own and do not feel isolated. They talk about their work habits, how they get their art out to the public, how they have been treated by critics. They talk about aesthetics and the impact of women on current and future art. They talk about their stumbling blocks, their politics, their futures. They talk about ambition, obsession, and intention.

You cannot travel from one country to the next without a document that verifies your citizenship. And yet in moving from one life to another, these women had only the unrecorded histories of their former lives as passports. I am in awe of their accomplishments as artists and their self-possession as women. The confluence of their work and their lives has given me a second education. I am proud to have the chance to give them the respect they deserve. They have become as the ten fingers of my hands, living with them as I have for the last two years. I hope they help guide your way into your own future.

Gloria Frym
Oakland, California
July, 1979

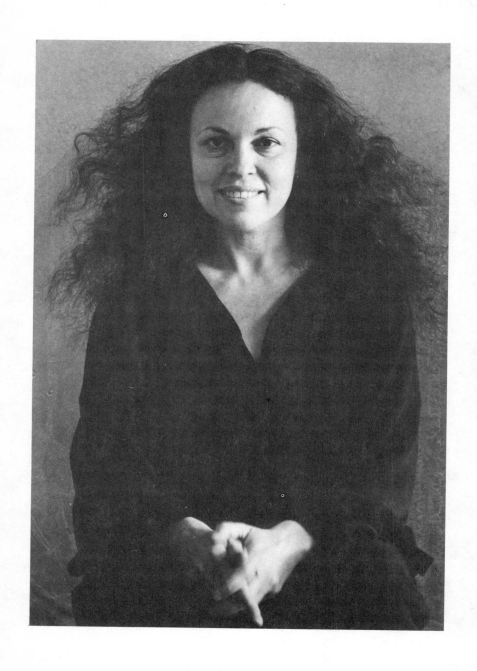

HELANE AYLON
Painter

One of fifty American women artists included in an on-going documentation by the National Archives, Helane Aylon has ten solo shows behind her in less than a decade of professional work. She was born and married into a highly religious community that discouraged her art, and she did not begin painting commissioned murals until she was well into her thirties. In 1969, she rented her first studio. Struggling to emerge in the New York avant-garde for many years, Aylon had her first one-woman show at age thirty-nine.

Aylon, whose early work has been described by critics as "lyrical abstraction," studied with Abstract Expressionist Ad Reinhardt. Though imprecisely categorized as conceptual art, her work is about a concept. Her primary interest is in activating images that eventually assume their own natural shapes and textures. In order to explore this concept, she does not use a paintbrush or other conventional tools; rather, she pours linseed oil onto the paper backing of plexiglass. The images that form from the oil resonate through the reverse side of the plexiglass, creating certain primary shapes and textures— ovals, branches, cracks, and wrinkles—which resemble aerial views of landscape or veins in leaves.

Aylon has taught at Hunter College, San Francisco State University, and the California College of Arts and Crafts. She

From conversations during November, 1977, and December, 1978.

17

has received the MacDowell Colony Fellowship, grants from the National Endowment for the Arts, and the New York Council for the Arts Award (CAPS).

She has two children.

At a time of life when most artists begin to forge their careers, what were you doing in your twenties?

Of course, I was married. We had moved to Canada where I didn't know a soul. I had my first baby in a French hospital in Montreal—before I was twenty. A year and a half later I had another baby in Brooklyn in the same hospital I was born in. I was really busy with the children and I was totally involved with my husband's career.

What was your husband's career that you were so involved with?

You know that it is hard for me to make this public, but I'll do it anyway. He was an Orthodox rabbi. Well, that's over with. . . . I do not offer this information easily, but I know you will handle it carefully.

Can you tell me about your life?

It was his life but it became mine. I found a lot of beauty and meaning and associations. But as an individual I had to be very cautious—almost erased.

How?

I behaved according to what was expected of a rabbi's wife. I never spoke before others because my husband was the family spokesman—unless, of course, I was called upon to read the

invocation or some such thing. We went to about three weddings a week but I never danced—not even with my husband.

Where were you born and raised?

In Boro Park, which is a Jewish ghetto in Brooklyn. I lived on the same street from the time I was born until I got married. It never occurred to me, when I grew up, that I could have my own apartment some day. This was unheard of in my "circles." Naturally I was not allowed to consider an out-of-town college. (My parents didn't even think a local college was particularly necessary for a girl.) And they thought all kinds of catastrophes could happen if I left home: I might eat non-Kosher food—who knows whom I would meet?! The only way to get out of the house was to get married.

What was your position in the family? Were you considered a creative child?

I was designated the "artistic one" from the time I was five years old. At eight, I made a drawing of an uncle with his mustache and glasses and it looked exactly like him, so my mother put it under glass on the coffee table. I drew my grandmother with her *shaitel*, I drew my little sisters as they slept while I babysat, and copied the illustrations in *Ethics of the Fathers*, the one art book in the house. Pretty soon the bridge table and buffet were covered with drawings under the glass tops. One day when I was eleven I pulled them all out from under the glass and tore them up.

Why?

I think I felt that doing art this way with my mother displaying it was like playing the piano for company—it bothered me.

But wouldn't you say your parents approved of your making art by displaying it?

Helane Aylon 19

They approved as long as *I* didn't take it seriously. Art was considered an embellishment, a hobby, like some girls are born Hadassah leaders, some are cheerleaders, some valedictorians —Helane was artistic. You don't spend your time on art, you just *are* an artistic person. Art was never considered a worthy profession but it was kind of attractive as marriage bait. Think how nicely I could decorate the *Succa*!

Succa, *the little shack?*

Right, commemorating the temporary shacks that were built in the desert on the way to the Promised Land. We had one every year, for eight days, and I loved decorating it, as one might enjoy decorating a Christmas tree.

Were there art clubs you could have joined?

Once or twice I talked about going to an art club. But I got piano lessons instead, from Herman my third cousin! When I was thirteen, I wanted to try out for Music and Art High School. But the Hebrew principal of my elementary school thought it was too far and I wouldn't have time to continue with the Hebrew. The seventh grade English teacher told me two girls from my school had tried last year and were rejected. This was not good for the school's reputation, so was I sure I had a chance? I ended up going to a public high school three train stations away. After school I studied Hebrew and Mishna every night at the Hebrew high school.

Were you doing any art in high school?

I took one art class in high school. I copied Gauguin's glowing *Women of Tahiti*, trying oils for the first time. It wasn't an inspiring beginning because my art teacher made sexual advances towards me and tried to keep me after class. I was just fourteen. It was creepy going back to that class. I don't remember if I ever finished the painting.

Were you doing art while you were married?

I illustrated the Synagogue bulletin, if you call that art. I did ink drawings of the holidays. But I had my secret indulgence; I painted still lifes in oils. I tried to make the subject matter Sabbath candles because that seemed more okay to me. In the afternoons I worked in the front room so I could look out the window at the children playing outside. But around five o'clock I quickly put all the paints away. The house smelled from turpentine so I cooked something with garlic and opened the windows.

Would your husband get upset if he smelled paint?

He wouldn't be happy coming home to a house that smelled of paint. I don't think he wanted to contend with anything like that. Anyway, it was a small apartment and his study was the living room. There was no living room. But one fine day he thought I should have a college degree, so when my daughter started kindergarten, I became a student at Brooklyn College. I began taking art courses and then I had a place to paint.

That must have changed your life considerably.

I was a tourist in a wonderful world which I'd alight on briefly, then retreat, feed the kids and tend the house. You won't believe this—but I had not been to the Metropolitan Museum until I went for my art history course, at age twenty-six!

What did you do in the studio courses?

I began painting brides with veils. I think that's when I started getting a feeling about transparencies. I studied with Ad Reinhardt until I graduated in 1960. [Note: Rabbi Fisch died in 1961.]

When did you begin to think of yourself as an artist?

I don't know. Maybe after I changed my name. My maiden name was Heléne Greenfield. Heléne was okay and still is by me. (I might just change it to Helane next month just to train people not to say "Heleen.") [She did—G.F.] But Greenfield —my maiden name—is another story. It connotes this little trio of Greenfield girls—me and my sisters. And to be "Mrs. Fisch" was not my idea of who I was as an artist. My new name came about after '63 when I painted murals in the children's ward of Hadassah Hospital in Jerusalem. The hospital kids—both Arab and Jewish—would get wheeled into the hall to watch me work. They called me Doda Aylonna, which means Aunt Helane in Hebrew. A year later I did a mural in Bedford-Stuyvesant for a high school drop-out center. Some newspaper person photographed me surrounded by the kids and when he wanted to do a story, he asked me my name. I knew that was the very time for my declaration of independence. I might have said Helene Smith—or *anything*, but somehow I found myself thinking "Heléne, Heléne, Doda Aylonna, Heléne Aylon."

How did you feel?

Excited, a bit scared. I started writing my new name over and over on pieces of paper, the way we used to. Remember how we wrote our names, our boyfriends' names, how does that sound, how does that look, how would it be if our names were combined in marriage? I guess I was thinking, how will it be now that I am this new person? But my family was horrified; I had been a widow, Mrs. Fisch, for four years, and what was this about, suddenly? The next day when the story of the mural came out in the newspaper, two people called my mother asking if I'd remarried! To change your name in those days was sacrilegious; now it's feminist.

And soon after, you became an artist. . . .

In 1964 I saw chapels being built at Kennedy Airport. I drove along the Belt Parkway and kept thinking, I want to do art in a

chapel, and bridge the two existences and make sense out of my former life, improve on it. For once, let there be a universal temple rather than a *shul*. I made drawings and managed to show them to the architect and board of directors. They finally commissioned me to paint the library wall. I painted the word *"ruach"* which means "spirit" and "wind" and "breath." I painted the three letters of *ruach* over and over again in transparent layers. The image looked like it was painted from the other side; it had an invisibility at first glance—a fogging-out and reclarification which probably led to the work years later, didn't it? My teacher at Brooklyn College, Ad Reinhardt, came to see the mural, and there was an article on it in *Art News*.

You had done other commissions before, hadn't you?

Small projects, an old age home. No matter what you paint, it could look like the hereafter! So I painted umbrellas and teacups —no one could read anything into that. Then, there was a commission in a hospital to paint the sweet, pastel babies' nursery. I had to wear a mask over my mouth, even when the babies weren't in the room. Next, in a community hospital waiting room that didn't have windows, I was supposed to paint the outdoors, so there's a Corot kind of vista in New Jersey! The last one I ever did was at NYU Medical Center, but I pretty much was able to do what I wanted; it was done in 1967.

It's been referred to as one of the first lyrical abstractionist paintings.

Yes.

Were you doing your own work at that time?

No. The reason I looked to work on buildings was because I couldn't work at home. And it never occurred to me to have a studio. How could I be just an artist when I had two kids to support? Painting was an indulgence.

Helane Aylon 23

When did you get your first studio?

In 1968. My children were sixteen and seventeen when, for the very first time in my life, I had my own space. It was in the East Side, on St. Mark's Place, four flights up. When I looked out the window, the street seemed like a huge carnival, an Ensor painting. It was wonderfully scary. I'd given myself permission to be an artist.

How did your working outside your home affect your children?

They were still going to yeshiva, they had Orthodox friends, and I'd go to a PTA meeting looking very different from the other parents. I was beginning to change. My children were too old for babysitters, so they'd be left alone for long periods of time. I'd see them off to school each morning, travel to the studio, meander around to get my bearings, do some work, and suddenly it was time to leave. I'd drive home around rush hour— start dinner at 8 o'clock at night sometimes. There was no way to resolve it because I knew I couldn't work in the house and they would not move to Manhattan because their life and friends were in Brooklyn. It was a difficult time for all of us. I felt guilty being away from them in my studio but when I was not in the studio for a time I'd feel pulled away from the work. Even now as I tell you this, I feel guilty for telling you. But I suppose if my son is already a Ph.D. in plasma physics and doing research at Princeton, and if my daughter is forging new ground in drama therapy, they must be grown up, and enough time has passed to be able to look back.

So when you finally started working at the studio, what did you paint?

I made a painting that was really a fountain. I used three layers of plexiglass, each dabbed with spots of transparent glue which looked like drops of water. Then I staggered it with the help of a

mechanical friend so that drops of real water would fall at different time sequences on the three layers. One couldn't know if and when a drop would fall. The fountain had its own mind. Sometimes it would get clogged up and nothing would happen. Another thing I did was scratch the coating on three layers of mylar and stretch these over flourescent lights on the floor. It was like a lake you could look down into ad infinitum. After all this I started the silver paintings.

Which eventually got shown at Max Hutchinson.

Right. They were transparencies of layered plexiglass over metal. Then I just painted on the metal alone and cracked the paint off with heat. The metal shone through the cracks. I guess elusive light and shifting imagery were always there. And the look of natural cracks.

Did you speak to other artists about your work?

In the beginning, nobody; I knew no one in the art world at that time.

Did you try to get a gallery to show your work?

When I had a body of work, I started to go to galleries. Of course, I didn't know which ones to go to; I probably started with Marlboro! (*Laughter*) Once I went to the Ruth White gallery and was told, "We already have our quota of two women artists," and I said, "Oh sure, of course," not even knowing how depressed I was. At that time there was no such word as "sexism" to clarify the issue. But there always is something good to balance the negative. I chanced on Bykert Gallery and met Klaus Kurtiss. He came to my studio in a blizzard and really looked. The work was too romantic for Bykert, but it was taken seriously by someone I respected.

How did you finally show at Max Hutchinson Gallery?

A neighbor artist, Clement Meadmore, saw my work and hung one of the pieces in his place. It was seen by his dealer, Max Hutchinson. The painting grew on Max every time he visited Clem. Not long after, Max called me to show at his gallery. The minute I got into that gallery, I really started working. I decided I was never going to take another commission, I really started feeling like an artist because I was decreed an artist. My first solo show was in 1970.

What became of the early paintings, the brides?

I'm afraid I destroyed almost all of them. In 1970 when I moved to Westbeth (an artists' housing project on the lower West side of Manhattan) some got put into an incinerator; in 1969 when I moved out of my Brooklyn house, I left all the work by the garbage cans and watched at the window as a peddler went away with them in his horse and pushcart chanting "I cash clothes." I felt then that the paintings were too personal. Now they would be considered feminist, especially the brides. It's really hard to talk about this.

How did it feel breaking into the gallery scene?

I had to break from one life to another. If you walk into a gallery looking like a housewife—feeling like a housewife—there's no way anyone will take you seriously. When you have two children and you're a woman, the umbilical cord is still there. And it's never just the art, it's the legends that go along with the art; you almost have to have an added persona.

Do you mean that an artist needs a separate persona to slip into like an actress slips into a part?

Just think of Larry Rivers, Andy Warhol, Rauschenberg . . . there's that personality cult, that aura, that goes along with their art. Women, I hope, will change all this.

Are you saying that the personality cult is detrimental to art and women artists?

It's a strain to have to live up to a legend. You know there's a real snobbishness in most galleries. You feel you have to walk on tiptoe. And the galleries feed into the images, the exaggerations, making the artist legend or zero.

Did you feel that way when you got a gallery?

I was made to feel it was a privilege to show in a gallery. I was told I was very fussy. Isn't that a funny word? Translated into male language, it would read "highly principled."

Why did you move to California?

To test myself in a new place. To cross a desert. If I had known then that feminism would improve the scene in New York as much as it has, I might not have moved.

How do you feel about allying yourself with those women whose roots in art come by way of feminism?

Very comfortable.

Even at the risk of being taken less seriously by the art community?

As far as I'm concerned, feminism at its best is what's going to change the world, and it's going to change art. I'd rather choose life than worry about the art community.

What do you mean by "feminism at its best?"

In terms of the art, I'm not referring to overt vulva art, and I think the period of explaining and wailing on shoulders is over.

What's replacing that?

Here's one simple thing: We're getting healthy and we're making everybody else healthier by bringing fresh air to a stuffy art world.

You still haven't defined feminist art. Can you?

No, not without being simplistic. There's the feminist issue, which is political, and there's the feminine, which I see as a spiritual dimension in both men and women.

What do you mean by the spiritual dimension?

I'd say there's this largeness, this emptiness—a void, which is also an openness to experience. It's not absolute, or dogmatic. It has to do with knowing without a fixed point of view. There's a wisdom, another kind of intelligence; there are other quests— more generative, more pervading. There are other spaces, and other ways of encompassing the world and ordering it.

This is relevant to all the arts.

Yes. But sometimes I don't like the term "woman writer" or "woman artist." This implies that there's a particular kind of women's work—instantly recognizable—no matter where she is from, no matter her situation. It doesn't take into account the endless variety of fifty percent of the human race. There's now a term called "classical feminism" which has a deeper connotation.

What do you mean by "classical feminism?"

It's a cultural force, it's a consciousness without labels and expectations and a "look."

Earlier you spoke of transferring your spiritual search from religion to art.

You know, I really dislike the word "religion," and the word "art" almost makes me nauseous. I don't like the word "spiritual" (though I just kept talking about it), but I do like the word "search."

Okay, how would you define your "search?" (Laughter)

Okay. My search: I've been looking for natural laws. First, in the early work and those elusive silver paintings and the large metal works, I explored how light glimmers through and how it's dependent on something external, like where the viewer stands. I'd subtly buckle two pieces of metal and compare how they differed because of the light hitting them. Then in the paintings that change in time, I was looking to see how things transform involuntarily. They stained through in their own way; the paper creased and air pockets formed without my hands. Even early on I blotted globs of paint and they formed branch-like images. It's the natural handwriting of the world—branches and cracks. Back to your question about the search. You know, I'd like to think the Hebrew word for "art"—"amanute"—comes from the root, "amen"—"so be it." My relying so much on materials and time—maybe that's an act of faith.

Harold Rosenberg, the critic, talked about loosening the hold of the artist on the work. Is that also what you're doing?

It's precisely what I'm doing—eliminating *my* scribble, *my* image, *my* handwriting. For instance, what I'm starting to do now is pour oil in a straight line, and it forms a pool. That's its own natural shape. If the oil dries on top, forming a layer of skin, that's its natural texture. And if I lift the panel and the skin breaks because of gravity, (and each time the skin does break differently)—it's the natural forces that have caused these images.

You've worked with images that are relatively fragile. How do you feel about art and immortality?

It's conceited for an artist to think that what he or she does is immortal. Everything changes. For instance, DeKooning was my hero at one time. I look at him now and I see the way the bodies of his women are torn apart. I've heard that he starts a work with the mouth of a woman, then slashes it over and over with strokes. Psychologists might call this vagina dentata agitation! So I can't appreciate him in the same way I did before feminism. All work gets new implications put into it. Carol Duncan writes about the French salon painting which often depicted old men, and this alluded to the reactionary status quo. Seen centuries later, we might think it alluded to saintly sages.

Then art isn't as precious as it's made out to be.

Exactly. Every great art both recognizes and annihilates the art that came before it. When Jackson Pollock dropped his paint across those big canvases, he *cut out* everything before him. He also started something: the gesture, *extending* art. When Ad Reinhardt did all black paintings, he said, This is it, no more signatures, no more expressiveness. He just about obliterated art, and the artist, and himself. But he found a great purity in this leap. These two artists have been important to me because they have not been afraid of a void, of scribbling over themselves, of darkening themselves out.

In dealing with the void, there must be fears and doubts.

Sure, the moment when the thought comes that all these years have been for naught—little things like that! The moments of worrying whether the art will last, whether I will last. Worrying about getting reactions from critics and collectors and the NEA and faculties and galleries and everything and everybody. Better to rely on friends and on oneself. But, damn it, you can't, you need the whole thing.

Actually, the critics have been good to you, haven't they?

Yes, they've been very good, both male and female.

But you still had to promote yourself.

Promoting is very demoralizing, but it is necessary. Writers have to keep sending out manuscripts and getting them returned. Artists must find teaching jobs, which are scarce. The galleries are overcrowded and ruthless unless you sell well. You know all that . . . ho-hum. God, what dumb work, sending out slides. I think it's not the good reviews. It's either doing mainstream art or being in a good gallery. If you're in one of the magic six galleries, you can breathe without having to spurt your own name with each breath.

What's the proportion of time you spend, not actually doing your work, but hustling?

Sometimes it feels like my whole life, and sometimes I say fuck it. Sending out those letters and slides is like working as a secretary, even though the boss is me.

What do you need to be able to continue your art fulltime?

Myself—that is, my self. A clear head. A large work space. No anxieties about money. Oh, utopia. A teaching job where I wouldn't have to hide my feminism to keep the job, because I love intense relationships with my students.

What happens when you don't work for awhile?

I feel like the time wasn't accounted for.

What do you think is the most difficult thing you have to overcome in order to make art?

Day-to-day isolation. Of course, that is also the best part of

being an artist. When it's good and I'm working well and totally alone it's like the feeling you get when you hear the *Magnificat* by Bach. I'm so grateful. When it's bad, it's a dungeon. I wonder why I'm locking myself away from the world. To do what? For what? That's why I need to teach—to give, to love.

Isn't that the paradox of being an artist? Would you have it any other way if you could?

Well, the art dictates how to have it. I can't dictate. If I needed to photograph elephants, I might be travelling in Africa now.

You've been a serious artist for ten years now.

A long time. It's like marriage vows, for better or worse. You just continue, no matter what comes of it. It's a lifelong commitment, a search that matters more than sacrifices, more than isolation.

Helane Aylon (b. 1931)

Exhibitions
1970 Max Hutchinson Gallery, New York
1972 Max Hutchinson Gallery, New York
1973 Tower Gallery, Southhampton, New York
1975 Betty Parsons Gallery, New York
1975 Susan Caldwell Gallery, New York
1976 Grapestake Gallery, San Francisco
1976 MIT, Cambridge
1978 Grapestake Gallery, San Francisco
1979 Betty Parsons Gallery, New York
1979 112 Greene (now called 112 Workshop), New York

Group Shows
1970 "Lyrical Abstraction," Larry Aldrich Museum,
 Connecticut
 Phoenix Museum of Art, Phoenix
 Philadelphia Civic Center, Philadelphia
 Whitney Museum of American Art, New York
 "The Art Scene," Berenson Gallery, New York
 "Group 70," Max Hutchinson Gallery, New York
 "Two Generations of Color Painting," University of
 Pennsylvania, Philadelphia
1971 The Members Gallery, Albright Knox Art Gallery,
 Buffalo, New York
 "Beaux Arts 25th Anniversary Exhibition," Columbus
 Gallery of Fine Arts, Columbus, Ohio
 "Season's Highlights," Larry Aldrich Museum,
 Connecticut
 Group Show, Max Hutchinson Gallery, New York
 "4 Painters," Skidmore College, Saratoga Springs,
 New York
1972 "Painting & Sculpture Today 1972," Indianapolis
 Museum of Art, Indiana
 "Soho Scene," Storm King Art Center, Mountain-
 ville, New York
 "New Instructors, New Media," Brooklyn Museum,
 New York
1975 "6 Painters, 6 Attitudes," Oakland Museum,
 California
 "Color, Light, and Image," Women's Interart
 Center, New York
1976 "Abstraction in Metal, on Canvas and Paper," Dart
 Gallery, Chicago
 Studio School Invitational, Fourcade Droll,
 New York
 "Works on Paper," Ruth S. Schaffner Gallery,
 Los Angeles
1977 WCA, Contemporary Issues: Work on Paper,
 Women's Building, Los Angeles
 The Artist's Book, Mandeville Art Gallery,
 University of California, San Diego

WCA, Contemporary Issues: Work on Paper,
University of Houston, Texas; University of Utah
Holiday Exhibition, San Francisco Museum of
Modern Art
"Fall 1977 Contemporary Collections," Aldrich
Museum, Connecticut

1978 9 Artists' Books, Dalhousie University, Nova
Scotia; University of California, Irvine; Oberlin
College; University of Wisconsin
"Metamagic," California State University,
Dominguez Hills
"Sketch Books," Women Artists Archives, Women's
Interart Center, New York

1979 "New York—A Selection from the Last Ten Years,"
Otis Art Institute, Los Angeles

Commissions
1966 Chapel, John F. Kennedy Airport, Mural for
Library
1968 New York University Medical Center
1978 San Francisco Airport

Public Collections
New York University
Whitney Museum of American Art
Westinghouse Corporation of America
New Museum of Contemporary Art, Haifa, Israel
Oakland Museum
Massachusetts Institute of Technology
Skidmore, Owens, & Merrill, Harris Bank, Chicago
Maurice Templeman, New York
Baker & Betts, Houston

Grants
1972 MacDowell Fellowship
1973 National Endowment for the Arts
1974, 1975 National Endowment for the Arts, Faculty
Development Funds for Teaching
1977 San Francisco Arts Commission

34 Second Stories

1978 CAPS (New York Council for the Arts)

Acknowledgements
1973, 1976, 1978 *Who's Who in American Art*
 One of fifty selected women artists documented for
 the National Archives

Publications
Visual Dialog, "Sex Discrimination," Spring 1977
Womanart, "Interview with Betty Parsons," Fall 1977

BEATRICE BERLIN
Printmaker

Beatrice Berlin was born in 1922 in Philadelphia, where she spent much of her life. She attended Moore College of Art and Philadelphia College of Art and she studied with printmakers Sam Maitin and Hitoshi Nakazato. Her work has enjoyed twenty-one solo invitational exhibits on the East Coast, as well as a dozen group and juried shows. She has received many print-making awards and her prints can be seen in the collections of the Philadelphia Museum of Art, the Brooklyn Art Museum, Temple University, RCA, and a dozen other public and private institutions. Included in *Who's Who in American Art*, Berlin is also a member of the California Society of Printmakers. She is married and has two daughters. Beatrice Berlin makes three-dimensional, embossed prints of simplified landscape forms. She is preoccupied with color and shape relationships. Her work has changed dramatically in the past five years, moving from spiraling plant, rock, and shell formations to broad mountain and horizon abstractions. Her former use of bold oranges and reds has quieted into subtler earthtones in her most recent work.

From conversations during April and May, 1978.

How did you come to take art seriously?

It wasn't an overnight sort of thing . . . I had art in mind before
I had any children. When I was in high school, I majored in art.
I even got a scholarhip to a good art school, but my parents
weren't very encouraging. Money was tight in 1940 and art was
of no use to a woman. They wanted me to go to business school.
I refused. My mother looked down her nose at artists not
because of what they created, but just because they couldn't
make a living. We had an artist next door to us who had a
terrible time.

Were you making art when you were a child?

Yes, but I concentrated on designing dresses. I was a good
seamstress, so I learned how to make patterns. I had the ability
to paint, but you have to remember, there was a depression
going on.

How did you make money during the war?

Everybody knew you couldn't sell art, but there was money in
dress designing. I figured I would put together my ability to sew
and my artistic ability. I envisioned myself as a famous dress
designer. I actually did some pretty nice designs, but during the
war I did mechanical drafting. I got married. At one point I had
my own business, working out of my house. I even worked for
someone else designing maternity clothes.

*Working and making a living seemed to be a big concern
for you even when you got married?*

I had always felt that in order to be respected, I had to be useful,
and if I had no job and couldn't be earning money, I wasn't
useful. My first husband was a salesman. We always struggled
with money. When I got laid off, I thought to myself, I've been
married four years and I've been putting off having a baby
because I wasn't even sure I wanted to be married! What I really
want is to work and nobody wants to hire me. All these things

went through my mind, so I said okay, well, now is the time to have a baby.

Did the prospect of maternity replace your desire to work in the world?

Well, getting pregnant did have to do with self-respect or self-image for me. Then I got involved with the baby and with house-work and gradually lost interest in the fashion business. In fact, I did a complete turnaround. I began to despise fashion.

Why? Because of its faddishness or the business itself or the design making?

I think it was the whole idea of decorating the body and the vanity that comes into play. To give such importance to deco-rating the human body was not one of my values.

What do you suppose caused you to change your attitude, especially since you had been sewing all your life? When did this change in values take place?

Probably somewhere around the age of thirty—midway be-tween the births of my daughters. I just wanted nothing more to do with fashion. I even lost interest in making clothes for myself.

Would you say you were, at one time, more interested in the design than in the actual fashion?

Maybe. My designs were structural . . . draped and curving lines. I was never concerned with decorative types of patterns.

Do you see any connection between what you used to design in clothing and what you've done in printmaking?

Very much. I have a sketchbook of designs and anyone can see the similarities. Also, the skill I achieved as a pattern maker I now put into making my plates. Perhaps printmakers who

haven't had that kind of training wouldn't be able to make plates the way I do. I make them to get everything to fit right.

It seems to take a certain kind of temperament, a predilection for precision, to make those kinds of plates. . . .

It takes a basic talent for visualization, something that is inborn. You imagine an image or you look at an object. Then you have to do a drawing of it, showing the top plane, the bottom plane, the side plane, as well as the front plane . . . that's visualization. A person who has that talent can visualize how the image will look. Even though you don't see the image yet, you can visualize how it will be and put it down so that it will work. I could visualize early on. I just didn't use my ability for periods of time.

What happened after you had your first child? You weren't making art at that time, I assume.

I hadn't done any painting since I got out of high school. Then a year of art school and then no painting at all. We moved to a tract in Pennsylvania. Somebody had started a little art group which I joined and I started doing watercolors again. Just very amateurish stuff. I wasn't proud of any of my efforts but I painted one night a week. Just to pass the time. Something to give me relief from the child-raising, the housekeeping.

Well, that's better than playing cards.

I thought so. That was in 1953. I started an occasional painting at home and got opposition from my first husband, who didn't like me to get serious about it.

Why?

Well, because it was time and attention away from him! What-

ever it was, we had a battle and as the years went on the battle went on.

The battle was actually between you and your art and him?

That's the way he put it. He was also battling me because after the birth of our second child, the money got very scarce. I ran an ad to do alterations for other people. I began doing these alterations to make extra money and he complained because he couldn't stand the sound of the sewing machine and he thought such work was very demeaning. And for some reason, I couldn't ask for money, I could never ask him for money.

Did you work outside your home during the time you were raising children?

In 1963 I went on two job interviews. I was trying for a job in drafting or technical illustration. In both interviews the personnel manager was very concerned that I had two small children at home. Who would take care of them? he kept asking me. He liked my samples and it seemed certain I'd hear from him and I never did.

It might not be much of a comfort, but what you went through helps make it possible for women not to have to suffer that kind of thing today.

Well, it all led to something else. Had I been hired, perhaps I wouldn't be where I am right now! After that job-searching ordeal, I got into a basic printmaking class. I was forty-one years old. The reason I got into the class was *not* because I wanted to learn printmaking but because the class was mis-advertised as basic drawing. I liked the teacher so I stayed.

This was the real turning point for you?

My teacher said I had a lot of promise. He said, I'd like to have a particular print of yours and if you want I will trade you one of mine for it or buy it from you. Well, I said, I would rather trade. And he invited me to his studio. You know, that was the first person to ever really encourage me. He introduced me to a gallery, he showed me how to present my work, how to mat it and so forth. The gallery took me on. It took a long time before they started selling very much. I had been doing watercolors and had even sold a few but it wasn't till then that I realized that a professional has to be dedicated to his or her work. . . .

What else do you think goes into regarding yourself as a professional? What do you mean by professional?

I have my own standards, and as a professional I have to be very critical of my work. A professional doesn't show anything that she really doesn't think lives up to her standards. She's got to be able to look at the work with a very cold-blooded eye.

You're saying that a professional is her own editor and critic?

I would say that self-criticism is very important. That is, if an artist is dependent on the guidance of a teacher, the artist can't really be called a professional. You may like to think of yourself as a serious artist, but until you can discard work when it isn't up to your standards, you're not serious.

Of course, there's another kind of professional, the kind who latches onto a gimmick or an idea that the public wants and does it repeatedly to make money: these I call popularizers. I don't sneer at this, because a person's got to earn a living, but that's another kind of professional.

Is this a liability of printmaking? You can feed the public with the same image over and over again. . . .

Well, yes, that sort of thing is done, but there's a differ-

ence between printmaking and offset reproduction. Right now prints are being marketed which are really reproductions of other people's paintings and drawings. They call them prints or lithographs but they are really offset reproductions. Unscrupulous publishers are putting them out, and the artists, in order to make money, allow the publishers to do a large edition . . . thousands maybe . . . and then the artists sign them. You've probably seen those Wyeth prints. Wyeth never made a print in his life. He signs those offset reproductions and people buy them for a lot of money and what they're buying is a signature. An artist who is not a printmaker can make much more money than an ordinary printmaker who prints his or her own work. The printmaker who makes a plate can make a small edition, maybe up to fifty or so. When I first started printmaking, I would make the kind of print I thought people wanted. I didn't look upon my work as great art, I just needed the money.

How does a printmaker know what people want and what's going to sell?

Ask any artist who has been around and they'll tell you what sells: nostalgia. People who don't know very much about art will say, oh! this child reminds me of my child, oh! this scene reminds me of a place I've been. . . .

So you directed your energies into the commercial when you first began?

Well, my subject matter was chosen with an eye to the customer. I built up a following over a period of a few years, from the first time I put my work out in 1963 until about 1968 . . . and I was getting increasingly disgusted. I did not want to continue to do this, I was looking for something else. I found I didn't have respect for myself.

Did you make a distinction between you as a creative artist and you as the person making money?

I don't know. I know that I did not respect myself as an artist. I felt, if this is the best I can do then I'm not very much. I felt this in spite of the fact that people kept telling me that I was very good and that they loved my work. I did not think very well of myself.

Was that because you weren't getting reinforcement from the kind of people you really wanted to acknowledge you?

That's probably what it was.

Did you make a distinction between your own work and the work you did to sell?

No, there was no distinction. I wanted to get into good juried shows. That was very important to me. I was painting at the same time. I had been in regional shows with some of my prints. In 1965 I hit it big with a painting in the National Academy of Design in New York and the same year I got a painting into the Academy of Fine Arts Annual in Philadephia. The next year one of my woodcuts got into the National Academy of Design. I realized that the piddling little prints I had been doing for money just had to go in some other direction or I had to do something else with my art while I did these prints . . . something I could take pride in.

So it was winning those awards that gave you enough reinforcement to work in another direction?

I got into the shows but I did not get awards. That's exactly what gave me reinforcement. Not winning the awards made me realize that I had the ability, that there was something there, but that I had to just keep working.

Now that you were getting some acclaim, to what extent did your domestic life affect your productivity? I assume your children were still at home.

I was able to shut the door literally and figuratively. I took care of my kids. I felt very strongly that I should, but even with them I could shut the door.

Did you feel obsessed with your work?

I've always been obsessive. That's a good word. I was obsessed when I was doing dress designing. For a brief period I did gardening and I was obsessed with that. When I started painting, I became obsessed with painting. I'm a person who gets obsessed!

It seems that every artist I've spoken with and every great artist I've read about expresses that same phenomenon, that making art requires a cutting off of other possibilities.

I never thought about it. I only know that other women I've spoken to who had families and wanted to make art have asked me what I did with the kids, and I have always said, you've got to be able to shut the door to the rest of the world, to the family and everything else. I had a studio upstairs back in 1967. I saved a thousand dollars to buy my own press. My studio was the room I went to and when I shut the door, the kids knew that mommy was there to talk to but mommy wasn't there to chauffeur them around because mommy was working.

Do you feel you have to consciously discipline yourself to do certain things regarding your art? How about the business side of the work? When you first started selling, did you consider yourself to be operating a business?

I had to because I was told that I must keep good records. Actually, I have always felt that it was necessary, so it's not exactly discipline. Printmakers have to be careful with numbering . . . if you print a plate a few times but you haven't finished your edition, you've got to keep a record of the number you've already printed. If you're going to be earning money and

considering yourself a professional, you have to consider income tax, you have to keep books. So I did.

Do you have a gallery selling your work for you?

My work is sold almost entirely in galleries. I don't sell out of my own house. I used to like to show my work to galleries, but I'm not getting as much good feedback in California as I did in the East.

Why is that?

I think it's because there are so many outlets with not enough customers! And so many artists competing and clawing tooth and nail here.

The public needs to be educated about art in general, and printmaking specifically. If there is less money in California for painting, prints would seem to be an inexpensive answer to original art. . . .

I agree, but as an artist, I can't educate people and do my work and sell it too! That's where the gallery should be, not just hustling but educating too. . . .

I get the impression that there are a lot of women print-makers. Is the ratio of women to men larger in printmaking than in the other visual arts?

I don't know for sure, but there are in fact an overwhelming number of printmakers who are women.

Why?

My thought is that men think in big terms . . . and printmaking is not important enough. If you want to be known as an artist,

don't be known as a printmaker . . . be known as a painter or a sculptor.

Do you feel that way?

I'm only telling you what one man, a very innovative artist, told me ten years ago.

What was his rationale?

Printmaking is a secondary art. It doesn't have the acceptance of the art establishment. If you are *only* a printmaker, unless you become very well known, really tops, you can't be taken seriously. This was how he put it.

Do you feel it's still true?

At that time maybe it was so. I think that real changes and innovations have only come in the last ten years. But no matter what, galleries can't make as much money selling prints as they can selling paintings.

So because printmaking is essentially non-commercial, it gets relegated to being a lesser art?

Well, maybe among artistic fashion arbiters.

There is a growing body of art criticism written by women, much of it with feminist perspectives. Do you feel any alliance with feminism as an artist?

If I felt that a feminist alliance would benefit me, yes. But I have a thing . . . I don't like to be known as a woman artist.

Well, that's what Georgia O'Keefe said too. . . .

I don't particularly like being associated with women artists. I joined the San Francisco Women Artists because somebody told me it was a good organization.

So what does it do for you?

I got into two shows and sold a print. But I still don't like being associated with just women.

Do you think it's limiting?

I think so.

Have you ever noticed that men respond to your images differently than women, or that men buy different prints than women do?

Oh yes, very much so. When I switched from realistic etchings and woodcuts to making abstract intaglio prints, I noticed a big change in my buying public. It took maybe a year. It was very slow and I wasn't selling much, except that the people who were now buying my work weren't the older folks looking for nostalgia. They were men or they were young couples. Once I was showing at a yearly outdoor show in Philadelphia, selling directly to the public. I saw men come in to buy.

Can you describe the transition you made that suddenly got men interested in your images?

The previous images were mostly children. They were representational and they weren't very large. The work after the transition was larger, much more colorful, non-objective forms, abstract. They gave the feeling of landscape and they were large flat areas of color with some texture . . . they had embossment and they were three-dimensional. I got a lot of attention from men who were fascinated and wanted to know about the technique.

Why do you suppose you made the change?

Well, previous to that I hadn't thought in terms of anything but realistic images. I had been taught to think in terms of design, but design always meant I would take a realistic image of something I'd seen and compose it on a plate and the color would become part of the design. I hadn't been taught to think in simple abstract terms. I picked up two books that showed me how to think differently! I was at the point where I didn't need a teacher, I could do my own critique.

What does art do for you?

It gives me a sense of identity.

That you are an artist?

Yes. I would rather not be *introduced* as an artist unless it's pertinent, unless it's to a person who would be interested in what I do. But that has nothing to do with identity, in the way I look at myself. I mean, I don't want to walk around with a sign saying I am an artist, a printmaker. I just feel my own self-worth; that's what I mean when I say identity.

When you weren't doing art, did you not feel a sense of identity?

No, when I was not doing art I was a mother and a housewife, formerly a dress designer, who had skills that weren't being used.

What happens to your identity when you're not making art?

There was a recent period of time when I didn't work. It was in 1973 and I was going along in high gear and my husband suddenly fell ill. I made a decision not to work. I felt that if I went

up to work in my studio, I'd feel guilty. I didn't want to be working because there he was, falling apart. . . .

Well, what did you do with your identity in the meantime?

I tried to keep my head above water. I resented not working. I was nasty and I found ways to undercut my husband and I wasn't a pleasant person to be around. I was, in short, bitchy.

What would you do if you didn't work, if you had to abandon your art?

The first thing that comes to mind is that I've got to make a living. I wouldn't have an income. I would take a brush-up course in mechanical drafting.

But what would that do for your identity?

Well, you see, in the past I suffered from a lack of feeling of worth as a human being. There was always that small voice saying, you're not much, you're not very good. I've come to realize that I have worth as an individual. But I have to keep working in order to survive.

What do you need to continue your work?

The most important thing I need is a feeling of space and freedom—and I don't mean physical space in a room. I need no pressure on me to fulfill domestic obligations. My husband says no matter what, I still do as I damn please anyway! I don't look at it that way. I do what I do because I have to do it. But I feel that I have the right, that it's my *right* to do it.

What kind of plans do you have for the future?

I have no plans. I'm past the point where I make plans. But I can

tell you what I would like to do. I'd like to see places I haven't seen before. I would like to take off so I could have the experience of living alone.

Georgia O'Keefe took off and spent summers in New Mexico and left Stieglitz in New York. She took off because she wanted to be alone. . . .

But he encouraged her. . . .

He did. So there was that feeling that the whole world was her pasture and she could roam.

I never had that. I'd like to get the feeling of total privacy. But maybe I'd be lonely as hell!

Beatrice Berlin (b. 1922)

Exhibitions
Juried
1965	Delaware Art Center Alliance
1965, 1966	New York National Academy of Design, Annual
1965, 1969	Pennsylvania Academy of Fine Art, Biennial
1968	New Jersey State Museum, Annual
1969	Library of Congress, 21st National Print Show
1969,1973,1975	Philadelphia Print Club, Annual
1969-1976	Philadelphia Water Color Club, Annual
1970,1971,1973	Cheltenham Art Center, Pennsylvania
1971-1976	American Color Print Society, Annual, Philadelphia, Pennsylvania
1973	Hunterdon Art Center National Print, Annual, Clinton, New Jersey.

Group Invitational
Lehigh University, Pennsylvania
New Jersey Health Center
Philadelphia Art Alliance
Associated American Artists
Philadelphia Main Library
Monmouth, New Jersey Museum

Solo Invitational
Twenty-one exhibits between 1965 and 1976 in private galleries and public institutions.

Public Collections
Philadelphia Museum of Art
Brooklyn Art Museum
New York Public Library
Philadelphia Main Library
De Cordova Museum of Art, Massachusetts
Grunwald Collection, University of South Carolina
Dean-Witter
Philadelphia National Bank
Lessing J. Rosenwald Collection
First Pennsylvania Bank
RCA
New Jersey State Museum (Trenton)
Temple University
Philadelphia Civic Center Museum
University of Pennsylvania: Wharton School and Law School
Lebanon Valley College, Pennsylvania
Ocean City, New Jersey Cultural Center

Awards

1966, 1968	Upper Moreland Schools (PA), 2 Purchase Prizes
1970	Cheltenham Art Centre Print Show, First Prize
1970	Atlantic City Boardwalk Show, First Prize in Graphica
1972	Hazelton Art League (PA), Purchase Prize
1973	Phillips Mill, New Hope (PA), Print Prize
1973	Lebanon Valley College (PA), Purchase Prize

| 1973 | Ocean City Boardwalk Show, "Best in Show" |
| 1976 | Philadelphia Water Color Club Prize for Drawing |

Memberships
Artist Equity Association
American Color Print Society
Philadelphia Water Color Club
Philadelphia Print Club
East Bay Artists Association
San Francisco Women Artists
California Society of Printmakers

Included in *Who's Who in American Art*
"Collograph Printmaking" (Wenniger, 1975), cover and color
plate

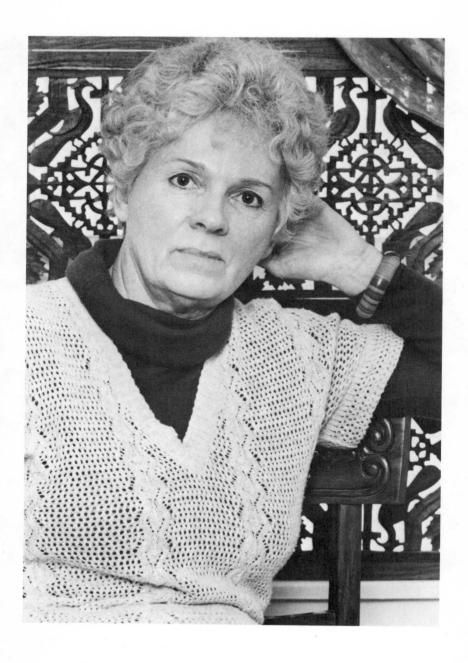

JOSEPHINE CARSON
Novelist

Josephine Carson was born in Tulsa, Oklahoma and educated at the University of Tulsa, and later at the University of California. In her early years, she worked as an X-ray technician, and during the Second World War, as an airplane mechanic and truckdriver. After the war, she moved to Los Angeles, where she held a series of jobs in libraries and bookstores. With the help of an older woman mentor, she put herself through a vigorous reading program and began to write short stories. When she was in her mid-thirties, her father died and left her a small income which enabled her to devote herself seriously to writing. Not long after, she published her first novel, when she was thirty-eight. One year later, she was awarded a Guggenheim Grant for Creative Fiction. Surrounded by storytellers in her youth, Carson relates, she never rushed to publish her work because for many years, she only half-consciously knew she was a writer.

Carson has published three novels, one book of non-fiction, and two plays. Her once oil-wealthy family suffered a severe financial and emotional collapse during the Depression, and their decline exerted a powerful lifelong influence on her creative work. Her books are informed by a strong sense of family and town as these social institutions are affected by global and current history. Her novels occur in Depression and World War II settings of the Plains and the Ozarks. Told through the

From conversations during June and July, 1979.

55

medium of several voices and points of view, Carson's works are fugues of the survivors who suffer the personal dilemmas of action versus inaction. Her brave female protagonists are engaged in self-reckoning crises, and much of their struggle is secretly focused on observing other characters whose failings they ultimately transcend.

In addition to the Guggenheim award, Carson has received Huntington Hartford, MacDowell Colony, and Yaddo Residence Fellowships. She has taught at Bennington College, San Francisco State University, and most recently at the University of California at Berkeley.

In your novels, your young female protagonists are writers. Did you write when you were a child?

Yes, I was always writing something, but I didn't really consider it writing. I was surrounded by storytellers. I would write little fragments, pieces of dialogue, descriptions of people, while sitting in class at school. As a small child I made up plays and songs and stories. Usually I paid very little attention in school after elementary grades, because it was never quite exciting enough. I was fourteen before I realized I could learn something of value to me in school. Once I heard the teacher say something interesting and I complained to a friend that I should have listened better because I wasn't going to remember all of it. She said, "Well, you can borrow my notes." I said—"*What* notes?" It shocked me to learn that the other students were taking notes on what the teacher said. I guess I always thought they were doing what I was doing, doodling, writing my little sketches. I was embarrassed and became very secretive after that, never let anybody see anything I wrote. You see, I was a rather wild kid. I couldn't submit easily to the structure of school. Yet I was strangely obedient. I rarely broke the rules, but I just didn't listen to what they said unless I had to. For that reason, very structured demanding work was more likely to make me struggle

—languages, math, science. There was no way to learn them by sleight of mind. I had to come out of my reverie. And also, after the age of twelve, I was chronically anxious about my family, which was falling apart because of the economic collapse of 1929.

You said you were surrounded by storytellers.

Yes. My mother's side of the family was very influential on my writing. When I was fourteen, my grandmother, who was about seventy-five, fell and broke her hip. She became much less mobile than before and then became a writer. She wrote three Gothic novels, dictated to me on the typewriter. She had no training and no self-consciousness. She knew nothing about what it meant to create a book, but she did it because she didn't know she couldn't. She never read, didn't even have a full high school education, but she had always made up stories.

What about your parents?

My father was a Canadian-Irish immigrant, also a great story-teller, and mimic, a great dandy, very much a liver. My mother was a sort of Southern belle. She wrote a couple of articles but never published them. She was a very creative person, but unmotivated and unable to bring off her writing. She had been the indulged youngest of a large family, brought up to be an art object. She was a natural visual artist, too; she could draw and paint, upholster. She was very theatrical and a fine natural psychologist. But she had no confidence in herself outside a protected domestic world.

Were you considered artistic?

I was considered a clown. And an actress. Everyone assumed I'd be an actress because I was a good mimic; I could sing and dance. But I was shy in certain ways which kept me from moving in that direction.

Were you encouraged?

I was encouraged to do what I pleased. I had quite a happy early childhood. But my parents were terribly indulgent and the pleasure principle operated so strongly in our lives that I was never motivated to stick with anything. If my parents had asked that I really try, I would have done it for them. Then, when I was about ten, the decisive point in our lives came, with the Depression. My father was wiped out economically. He had been a poor immigrant who made it in the oil business. He had the American Dream, and didn't believe that the great American business world could fail. That was the tragedy in my parents' lives and the beginning of their collapse. They both became alcoholics. They separated. My siblings also suffered a lot as a result of all this. My brother ultimately committed suicide.

Your books deal, in part, with a "coming of age" juncture in your heroines' lives. The Depression must have marked a particular traumatic point in your own adolescence.

It was the beginning of a period of heavy responsibility that I had to assume much earlier than was natural to me. After an indulgent childhood, I was almost totally neglected as an adolescent. We became very poor. And the Depression itself, with the sense of there being no future, no end to it, nothing happening in the world, was terrible for an adolescent. It was of course much worse for my parents. I lived in a boom town in the 1920s. Tulsa was extremely active and crazy and *nouveau riche*. Right in the middle of what had recently been Indian territory, skyscrapers were being built, often on mud streets. It was a very wild, active time, rough and celebratory. That quality of life before the Depression accustomed me to hyperaction. I was very excitable and excited about life, had an almost uncontrollable energy. And then to plunge into that big sleep of the Depression! After my father moved to the Ohio Valley, where he got back into the oil business, I was slowly and subtly selected to take his place. I had been his favorite. My mother

collapsed, became alcoholic, was ill a lot. I had to take care of her. My older sister was less independent and aggressive than I was and was eventually sent to New York to live with an aunt for a while. My brother was younger. He tried to take care of his own needs but ultimately he was the most damaged of all.

All through my life, since I had no children of my own, I expended a great deal of maternal energy on my family and became a sort of caretaker, especially of my mother, who became my child in a sense. Once I actually heard her refer to me, unconsciously, of course, as Mother. In a way the responsibility was good for me. The lack of authority made me extravagantly independent though, more so than was useful, and it made me very resistant, too, to any kind of manipulation or dominance.

Did you write during those years?

No, but I witnessed. My living was a witnessing. My mother was very dramatic about her needs and pains. Hers was a family of interesting hysterics. She was the youngest of five daughters and one son, and three of them committed suicide. That was the drama-in-the-making I was witnessing—besides the fall of my father, who had loved the good life and tried so hard to make us happy. He had supported someone since he was fourteen years old. But the facts of my mother's life had so much depth and structure that I displaced my center of attention from myself to her drama. It was a very powerful, lifelong influence on me as a writer. I became extremely observant, wary, and cautious of my mother. The more dependent she became, the more convinced I was that I could help her. Until the last few years, I often wondered if my own strength was an illusion.

Did you doubt your person or your art?

No, as soon as I began to write seriously, I felt I was a genuine artist. What I doubted was the extent of my strength. Because all the adults around me were collapsing, I had no practical models. I had to be the resuscitator and the survivor. My grand-

parents, however, were good if slightly removed models. They did not collapse.

Did you make any career plans after high school?

Not really. The Depression made that impossible. I was romantically interested in medicine. I considered trying to become a doctor, but I couldn't possibly have organized my life that way. I just liked the idea of it. By sheer necessity, I had been a good psychologist to my mother. A rich aunt sent me to college for a year and a half. Then I had to start bringing in money. I got a stupid job in a department store and wrote a fashion column for the newspaper. Then I persuaded a radiologist in Tulsa to give me X-ray training and I became a technician. I bought a new pair of shoes and a dress, and with sixty dollars in my pocket, I went to New York. I had a fabulous year. My first job was at the Talon Zipper Company, doing idiot work, calculating zipper footage. Then I worked in the New York Hospital at Cornell Medical Center. When World War II broke out, I returned to Tulsa and got a job at Douglas Aircraft, where I worked on airplanes and drove a big truck. Later I worked at a DuPont powder plant as an X-ray technician, and then moved to California with my sister and worked in bookstores. I tried to go back to school, at UCLA, but I was working full-time and it was too much. I got very involved in living so I gave up school.

Were you writing during this period?

I was writing poetry, terrible poetry, and I began to write a few stories with some effort and thought behind them. While I was working at Brentano's Bookstore in Beverly Hills, I met a woman who bought books from us there. She was the first intellectual older person I had had any sustained contact with and she briefly became a sort of mentor to me. I would say that I did the most concentrated reading of my adult life from about twenty-seven to thirty-five years of age; that is, I had much time and little responsibility beyond my jobs. I read lots of poetry,

memorized a great deal of it—Yeats, Hopkins, Eliot. I read a lot of English and Russian novelists, the usual. Also certain philosophy since this friend was interested in it—Pascal, Emerson, Santayana: random reading but a lot of it. That period was a kind of opening-up for me, a loose substitute for an education, I guess. I was also carrying on like crazy, changing jobs often, always having affairs. I was rather wild, but secretly I was serious.

Did you feel that you were living differently from most young women your age?

Yes, and I was a little envious of the ease with which other women seemed to settle down into domestic lives. But I thought of myself, from the beginning, as different. I was half childlike, even into my late twenties. It was very difficult for me to take myself seriously as a mature woman.

And therefore as an artist?

Well, no, but I had a stronger sense of myself as a *person*, than as either a female or an artist. The identity of female, possibly procreative, wife . . . that was dimmer to me.

In your first novel, the young female protagonist muses that the word "woman" isn't a word, but a name.

"Woman" was a difficult word to use in reference to myself for a long time.

When did you start taking yourself seriously as a woman?

I suppose about the time I started taking myself seriously as an artist. I had been working full-time at UCLA when my mother said, "I know you've been trying to write. I can't afford to help you here, but if we went to Mexico for a year, I could support you." So I went! We lived in San Miguel. I wrote sporadically:

I was having an affair with a refugee from the Spanish Civil War who lived at night. He came to see me at eleven p.m. and left at four a.m. and nearly ruined my life but it was wonderful! My mother had just come out of her alcoholism. We had been in Mexico almost a year when we got word that my father had died. We returned to the States. My father left me an income. That was when I was not only able to stop being employed for a while, but able to begin taking myself seriously as an independent adult and pursue life more on my own terms. I bought a house and that gave me a tremendous sense of being grown up. The income my father left me gave me time to write. I was in my early thirties by then.

Was it difficult for you to settle into writing after such active and flamboyant living?

Terribly, terribly hard. I had worked hard at all my jobs, I did them well, and people usually didn't fire me, I left. But to start writing all by myself! I had no discipline—that was the story of my youth! I couldn't sit down at a desk because I couldn't sit still! I had to have a desk built at stand-up height. I would sit on the edge of a high stool, so that I could be the same height as when I was pacing. I couldn't have done it otherwise.

Had you ever done any sustained writing before?

Several years before that, I had started a novel. I wrote about four chapters. I was on a train somewhere when I met the writer Hamilton Basso. I was drinking a beer and reading *The New Yorker* in the club car. He befriended me and when I told him I was trying to be a writer, he asked me to send him something, so I sent him pieces of that novel. He sent them to the just-retired editor-in-chief of Viking, Ben Huebsch, who read the manuscript and said that he greatly admired it as a first attempt, but that it wasn't ready yet, and that I'd be an interesting writer.

You didn't do anything with that early piece of luck?

Queerly enough, I took the editor's comments in a rather cool way. I wasn't in a hurry to score. I knew I wasn't ready. I didn't frantically try to continue my writing. I only half-consciously knew I was a writer.

Did you feel obsessively ambitious at any time?

No, it wasn't burning. It was more a need to do the thing that was natural to me, more that this is what I was and must do, not that I had to get a novel published. It wasn't an issue of success and fame with me, but just a feeling that I had to do this thing. Which was what all that undefined energy was all about, what was driving me. But I couldn't focus it then, not until I could get hold of my life.

When did you discover that the natural thing for you to do was writing?

I never really discovered it. It was just always true, and something I was slowly making conscious. Once I tried to open a charge account in a bookstore I had worked in. The assistant manager asked me to fill out a card. I looked at the blank that said "occupation" and I said, "Well, I'm not doing anything now but writing, so I'll put 'writer'." And he laughed with a bit of scorn. And I thought, Okay, baby. Two years later they gave me an autograph party for my first book!

So you started consciously thinking of yourself as a writer when you had an income that allowed you to write.

Yes. In effect, my father's death released me in a number of ways, mainly to write. I also started seeing a psychiatrist who was a great help to me. That's when I really began to write. And I met several writers and developed a wonderful friendship with three of them who lived together in a house. Two were already published novelists and one was later to become a poet. They were very important to my beginning as a writer, especially the

older one—Isabelle Ziegler. She was tremendously encouraging, a writer and teacher who influenced lots of young people of all kinds. I remember an interview with Ed Bullins by someone in *The New Yorker* some years ago. He mentions her as a great source of help and inspiration to him.

I also began meeting artists in Los Angeles—Renate Druks, a painter; Paul Mathisson, a designer; Anaïs Nin; the filmmaker Curtis Harrington. And halfway through my first novel, I met my husband-to-be.

When did you marry?

When I was thirty-six. I had lived with several men before. I suppose everyone thought I was very strange for not marrying earlier.

Did you want to get married before that?

I wanted to, yes, but I also wanted the kind of strength in a man that would not allow me to dominate him. That was almost impossible to find, because in those days, strong men didn't generally want strong women. And I wasn't a weak woman! I was far too independent for most men and gave the impression of being flighty although I was becoming quite stable by the age of thirty-three or so. But I think men felt they couldn't domesticate me. I destroyed several relationships before my marriage because I couldn't bear the thought of being manipulated. I was an unconscious feminist. It was easier to live with slightly older men.

Did you ever think to get married so that you could stop working and write?

I couldn't justify someone supporting me to do that secret thing that I wanted to do. Such a man would want me to put that particular psychic energy and time into raising a family and being his wife, and I knew that if I married him, I would use him

to do this other thing I wanted to do. There was no way I could tell any man that! But they all sensed it. They sensed that I wasn't about to be caught for their purposes. If they were going to catch me, they'd have to do it on my terms!

Did you finally marry on the terms you wanted?

Yes, to some degree. Suddenly after therapy, after this independence, the reason I thought I could marry was that I had established myself in my writing—it was no longer precarious —I knew that no one could ever interfere with it again. After I married, I sold my first novel almost immediately.

How did your success affect the early years of your marriage?

It was difficult for my husband. I had more success than he, and I was ten years older. He was trying to write movies and plays, but he was never as motivated as I was.

Was your life as a writer hard on your marriage?

Yes. And my marriage was hard on my life as a writer. But for quite a few years it was a good marriage. It didn't interfere much with the activity of my writing, but there were always psychological problems. And I'm very domestic too. So I put a lot of time into creating a home and cooking and all that. My husband was in most ways a very good companion. He was devoted and conscientious.

What are your feelings in general about being a woman, making art, and being married?

In general, I think it's almost impossible. I think you can *do* ten things but you can only *be* one thing. I'm not talking about the many people writing now who aren't artists. I do think artists are a different breed of human being. I think being an artist is a state

of being in which one is helplessly what one is; it's no better nor worse than any other state of being, but it is different. It's a natural anarchy. I believe that because I experience it every day. I think that's what stands between me and people who aren't artists. There is nothing unfathomable between me and other artists but there is a barrier between me and those who aren't. I have friends who aren't artists and I like and admire them and want them to understand me, but I don't think they can exactly. I think I can understand them a little better than they can me. Maybe that's a projection, I don't know. But I don't think we live in the same world. Therefore, if I lived with another person now, he would have to be an artist. But mainly, I think it's almost impossible for a woman artist to be a real wife and mother.

In the conventional sense?

Forget for a moment the historical habits and demands; I'm much more of a biological determinist than that. I really feel that I have an immense amount of natural desire to nourish— natural domesticity. If there is a person there for whom to make a domestic scene, I do it rather easily. It becomes habitual. And we turn into what we do. And also, I think there's something about the timing and rhythm of marriage that could be called prose and that the solitary life is poetry. Marriage has the structure, the rhythm, and the logic of prose. I think that marriage is not an anarchistic enough state for an artist to live in. And it's the capitulation of the body that marriage demands, ideally, of a young woman.

Even today, with styles of marriage changing?

It may be that more real artists are flourishing and influencing, making serious inroads into old styles of marriage. Perhaps artists set up patterns that others adopt. I don't know.

You did write two novels and one book of non-fiction while you were married.

Yes, and the three months of research it took me to do the non-fiction book almost broke up my marriage! I produced half the number of books I would have had I not been married. And certain qualified work. Some reviewer wrote that my second novel was, in part, an "act of will." True.

Were there occasions when you felt you compromised your career because of your marriage?

Yes, several. After my first novel came out, Stanford University asked me to apply for their writer's grant. They would have given me a degree and money. I could have used the guidance and education. I turned it down, though, because I was married and didn't feel I could drag my husband around for my purposes. He might have come along, but I thought that was a bad idea, although I followed him for his purposes a few times. Also, I received a Guggenheim grant at a time when my husband and I were particularly poor. I used that money to rent a larger house which gave me, for the first time, a private studio. Before that I had worked in a dining alcove or in the bedroom. In general, the grant helped improve our lives materially, and I don't resent that use of it because I was also able to justify avoiding employment. But naturally, if I had lived alone, that money would have given me more work time as a writer. I'm sure most husbands feel the same way about what happens to unexpected windfalls of this kind. And as I said before, my husband did not impede my writing—he was unusually generous and respectful about my work, he was proud of me. Our main difficulties came from the differences in our ages and our natures, our expectations.

What do you see as alternatives for a woman who wants to use her natural nurturing abilities, who wants an intimate partner, and who wants to make art as well?

I see possibility for marriage only if men go through the decompression chamber and move out of the patriarchal structures. I see hope for some women who can find the kinds of men they want to live with in a—oh, a less structured or less patriarchal way—only if the man is equally domestic perhaps, so that the couple isn't set up with polarized and therefore force-filled vacuums. In the classic situation, of course, the woman always rushes into the vacuum of that which the man cannot or will not do, and the man into the vacuum of what she does not do. Fortunately that's changing. I also feel that an artist must live a very independent life, married or not. A woman artist ought not to know the present condition of the socks and dishes and bank balance of her husband or lover. If you do not know those things about a man but do know the more important things—if you don't share the domestics on that level but do share lives—that may be ideal. It may be the only answer. Yet an old friend of mine rather convincingly argues with me that it's not their socks, it's their lives that are impossible! Anyway, I observe that most successful writers I know either have money, live alone and hire help, or have some kind of servant somewhere in the closet of their lives. They pay heavily for the service and women are still much more likely to become such servants than men are.

And then there's the whole issue of the Muse for a woman artist. It's an old fashioned idea but I experience something I can define only in that way. The Muse of the Western world at least is, in my estimation, female. Either you find the Muse in yourself, if you're a woman, or you find the Muse in the female aspect of your subject, or you find the Muse in the female part of your male mate, or you find it in another woman. It depends on who you are as to which one is possible for you. The finding of the Muse has as much to do with the troubles women have as artists as anything else. The whole thing is usually unconscious.

What about finding the Muse in other women?

It has been done. I think Virginia Woolf found her Muse in the

mother she adored and lost, in Stella her half-sister, in Vanessa, in Vita Sackville-West, in herself and in Leonard's *anima*, perhaps. Look at Edith Wharton. Where was her Muse? She had a devoted mother figure: a servant who lived with her and nourished her all her life. And she had two secretaries who between them covered thirty-five years of her life. Wharton lived in an essentially female household, with double support of the feminine in her life. While she sought intellectual male company, she had many close relationships with women. Her husband wasn't a dominant masculine figure on the domestic scene. She had an antagonistic relationship with her mother, but she was fortified by these companion figures. She was the center of a kind of literary world for a long time. She created the atmosphere to which many literary men gravitated, but it was *her* atmosphere. She woke up in the morning and gave orders to her housekeepers, but she stayed in bed and wrote all morning!

She never bogged herself down with domestic chores.

No! Of course she was rich. But she simply didn't enter the world of the fixed domestic role. She was economically protected from it. She had her own version of femininity and domesticity—never to serve anyone but a guest. The servants even stood between her and her husband. I think that's vitally important.

So in order to serve herself, the female artist has to free herself from the traditional servile role.

To serve herself and to keep her female core and essence intact and not disperse it among men and children if she's trying to use it in her art. It has to be a kind of unbroken pod; it's a form of psychic virginity, I think. And I think that one of the reasons I was able to risk living with a man the minute I got some start as a writer was that I had my writing going to a point where I knew I *could* keep it away from invasion. Of course, I had to slow it down. I've had to compromise. And I've had to deal with my

own basic limitations and the limitations of the life I decided to live.

This is perhaps one of the most serious issues for hetero-sexual women artists.

You can't take it too seriously. The beauty of your generation is that there's some possibility. Can you imagine me in Tulsa, Oklahoma, in the 1930s and 1940s, trying to take myself seriously as an artist? Anybody with any variation on the local bourgeois themes, anybody with any creativity really tried to get out of that town. There was no one to look to as model. I did have some bohemian and quasi-intellectual friends, but we were a small group and I was far more pagan than they were or knew I was. And of course you have to learn to sacrifice. I have to remind myself every day that my strength comes from concentration, from narrowing myself in on what I have chosen, and giving up all kinds of things, giving up diversions, giving up helping people. I still find myself spreading myself too thin, even so. I must constantly and ruthlessly cut all that stuff off, and, in other words, be as selfish as a man often is around his "career." A man is much more likely to be totally uncompromising. He's been bred as a keeper but not a server exactly, not a nourisher. You know how fatally attractive the maternal male is if he's very masculine!

Does teaching help channel some of your nurturing energy?

Yes, but it also interferes. I teach very little, by choice. I wasn't really trained to be a teacher. I'm a good teacher, but I don't want to do it full-time. I wouldn't even teach half-time if I didn't need the money. Of course, I've learned a lot from teaching; it has forced me to organize my thinking and structure my life in certain ways.

Have you ever been able to live off your writing completely?

No, but I've never tried and I refuse to because it means grinding it out. There are arguments in favor of doing that, it might have been good for me, and I did come close, but I couldn't quite bring it off.

Have you had to actively look for teaching jobs?

No. I made it known to a writer friend that I'd like to teach and was offered a job at San Francisco State. Once I was at Yaddo and casually mentioned I was running out of money and would need to teach soon. I heard while I was there about a job at Bennington and wound up teaching there for three years.

Was there ever a time in your writing life that you had to promote yourself?

Not really. I've sold all the books I've written. I've written some short stories and sold very few of them, but I'd say I've sold almost everything I tried to sell. I haven't hustled. I should have, a little. For me, it was always a matter of conserving time, and a certain shyness and lack of conviction about hustling. That's an agent's job, after all. Perhaps it's also that I feel that I'm still only learning to write a novel, that I'm learning something very big about the novel that I will know someday. I plan on writing at least four more.

How do you feel when you're working on a novel?

When I'm writing a novel, I have an immense happiness. I love my life then. During the time I'm living with the novel, I experience a kind of transcendence. I also write plays, and with them I have a certain excitement and feeling of competence, but it isn't that happy world I live in with the novel.

Do you think that women make art differently from men, both in the act of creation and the product?

Sure, why shouldn't they? I think it has to do with time and timing. The reason men are historians, for example, is not only that they have dominated all the intellectual fields. I think it's because men don't experience the ends of cycles in the way women do. Time to a male, I suspect, is a very long thing. The profound definition of time to a woman, I suspect, lies somewhere between the twenty-eight day cycle and the nine month cycle. We see some sort of time come to an end when something emerges from us physically. The moment that new life emerges is so dramatically available and visible and unqualified—the baby is either in or out—that perhaps woman's sense of time is based on these cycles in some way. I think that these cycles are abstract, whether we experience them or not—and we all go through some of them. Menopause, for example. I can't tell you how dramatically different my sense of time is now from what it was, say, four years ago. I'm very conscious now of having been propelled into eternity in some way. To another kind of time. I actually experience another kind of time.

What was your sense of time before menopause?

It was much more primitive, much more locked-in, much more physical. I felt I was always being had by nature, in a way. Now I feel that nature has very little use for me. In any case, I feel sprung from nature's motives now.

Is that a relief?

Partly. Nature no longer needs me as a breeder. After all, there was a time when women of my present age were facing death. I'm facing another piece of my life. Could be fifteen years or more of a pretty good life.

How do you experience the change as it affects your work?

It deepens my sense of history. And I am much more acutely able to appreciate beauty without there being a demand on me either to be part of it or to recreate it, although my creative abilities haven't diminished. My energy has, a little. But I had so much. I'm almost grateful to part with a little of it! I have a much more acute visual sense of the world and that may be because I'm not so urgently in need of making my life. Some of my students were here not long ago, and I suddenly thought, how weird of me to look at those kids and be able to see *nothing* wrong with them. *Nothing!* Either I have removed myself from their field of competition, or I have been released, in a way, from the general demands of the world. But I see perfections only hinted at before and they are not romantic. It is that I see more, more broadly. And I care less on an egotistical level.

In one of your books, you wrote that aging is not being able to live out the promise of the body, and that the body can not live out what the person knows.

Yes. That's the great human irony—we can't *be* what we *know*. I meant that the basic tragedy with which a human creature lives is his mortality. If you step off the wheel, if you're not so driven, as an observer you can have a tremendous amount of pleasure and fear in knowing that whatever the world is up to is not going to dramatically change your own life anymore. Whatever else nature does to you, it prepares you for your death finally. Marvelously and subtly. I take pleasure in the fact that I finally know something. When I was young, I knew what survivors know. I know something different now.

In your novels, you have portrayed a type of male who seems to be "on the way out," metaphorically speaking, a kind of

*character whose life is rapidly becoming anachronistic. I'm
thinking of the highly educated, wealthy, overbred patriarch
whose one regret is that he didn't know how to properly nurture
his progeny. In the end, he finally expresses a kind of secret im-
potency. What are you trying to do with this type of character?*

Such men are isolated by patriarchy and this isolation makes
them impotent. I think that that kind of male gave rise to my
generation of women. I don't think that our mothers really gave
rise to our consciousness as much as the combination of the
frontier male and the educated farmer did. They were alone
with their clans, they were the tribal chiefs, they were their own
establishment. My generation of women falls back on these
strange male models. I believe that the figure that gave rise to
the mind of the modern American woman is the man. After all,
it has been a patriarchal culture. There's no culture in the
Western world that has less of the female power in its soul and its
history than ours—the nature of the frontier created that im-
balance. In frontier culture, the woman was as much the man's
charge as the children were. And a hell of a lot of the westward
movement took place in large conclaves of men, men isolated
from women for long periods of time. And we have not had the
urge to create mythic heroic female figures—no Valkyries, no
Brunhildes, no Jean d'Arcs. We have a rather ineffectual Amelia
Earhart and our ailing failing movie queens. I think that my
generation of women is the first generally or broadly influential
generation of women in American history. The women of my
mother's generation had to make a huge leap into the twentieth
century from a Victorian rearing and that left them almost help-
less. Then the Depression and the Second World War finished
the job for them. One thing that probably strengthened my
generation is that we were forced to take on certain responsibil-
ities and to experience deprivation in our adolescence after
being raised during the indulgent 1920s. And then came the
War, which meant that we parted with an organized, predictable
society in relation to men. We had to protect, commiserate

with, and understand the male-turned-soldier on unusual terms. I was dealing with this in *Where You Goin, Girlie?* We had to become practical and base our decisions on the fact that the men weren't there. Those things strengthened us if they didn't kill us. I think our influence as a generation isn't fully recorded or tapped. And then stepping aside so the men could have their jobs back after the War forced us again to adapt and compromise. And yet in some psychological way, their going to war gave us a sense of freedom. We were released from the old role definitions a bit. We are the mothers of the new feminists and something in us gave them the conviction and energy to take the necessary risks. I don't give all the credit to the racial revolution for generating the feminist movement. I think the two reflect, however, a fatal crack in the ancient structure of patriarchy.

What's in store for the novel made by a woman?

Oh, who can tell? It seems to me that the current fashion for diary keeping and publishing and all the autobiography that pours out is just a fashion, a symptom that I doubt indicates any literary direction. We've always had it but Americans just now are excessively preoccupied with diaries, reading and writing them. It's a psycho-social matter.

You don't see a new literary genre emerging from the journal?

No, though I have a sense that the journal may help relate the novel to history again, in the way of the great eighteenth and nineteenth century bourgeois novels—those great loaded still ships that don't necessarily move very fast, but are essentially a picture of a social and historical world. I think there will be some kind of reëxamination of American life again and we'll drop the current attachment to style and the fictive essay.

We've lost the world of the town and the intimate knowledge of the middle of the country. We tend to treat our culture as if it

emanates entirely from urban coastal life and what we have in between is a sort of irrelevant swill of racism, redneckism, and a decadent consumerism. The only other part of the country that still has validity in the American imagination is the South.

I think we will tell stories about our life in the old way again, with the greater depth of our history alive in them. I have a kind of belief in the racial unconscious. I think we accumulate our past collectively and that we'll soon lose our confusion and fear of the preposterous and multifarious, complex American life that we have known, that we'll digest it in some way and begin to tell its stories again without nostalgia and romanticism. Our past is being mythicized and delineated now mainly in satirical writing and that's a very urban intellectual view of it. But the historical sum of the heartland is going to surface, I think, in the novel. I think of many attempts at it—a young writer named Woiwode for instance, and lots of unknown southern and southwestern writers are beginning to do it. The big family middle American novel might flourish again but as a quite different phenomenon.

What about the formal qualities of the novel?

Just as regards voice and style, it's quite possible that we will tap many more levels of the cinematic in literature, because of the influences of the cinematic approach to time. For instance, the film "Seven Beauties" interests me in its approach to time. It's like a series of stills in the heart of an action. I think that is in some way a feminine phenomenon, related perhaps to the way women see and experience time—the still thing in the middle of action, the surrounding of stills by motion. I think that something to do with altering time perceptions is going to come from women in all the arts. Maybe by expressing our particular time perceptions, women will alter linear sequencing. Take a book like Lessing's *The Golden Notebook*—for me it's like a city inside a womb. There's a vast stillness in it. The perception of time is the perception of history. And the perception of history is what will conceptually change in the novel. I don't anticipate

the novel's disappearance. But storytelling may alter dramatically as women find a way to use their peculiar time sense.

Your novels are set in what might be called regional America—the Plains and the Ozarks. Have you been termed regional by the critics? How has your work been treated in general?

There has been some reference to my work as regional, but it hasn't been damaging. One urban Jewish critic, for instance, thinks that I'm a very good writer but claims he isn't interested in my material. I think that's partly because he is urban and quite unfamiliar personally with the metaphors of my settings. He's an example of the person who doesn't really believe that the middle of this country is still real or perhaps ever was. And I doubt that since Willa Cather's work he has ever read a woman's perusal of a region on any but the literal level. And on the literal level it is defunct, in that everything has been said. What hasn't been said is how women lived what were supposedly masculine moments of history—war and so on. If we wait a quarter of a century the Plains may suddenly be utter historical past, and may be understood again on new terms. The South still has credibility, partly due to the civil rights movement, the emergence of blacks and the greater number of black fiction writers.

And then there's a move back to the town which may stir up some new cognizance of what Americans still are in their depths —mid-country, non-urban, formerly frontier-looking people of large families and much hope for the future; trusting isolationists. I'm not suggesting we should become that again but that we should give credence to it in our souls. We are so afraid of the past in this culture, so contemporary! It's a disease! We fear what we have too little of. And our past is pretty wild and hard to grasp.

But anyway, I think that all this personal diary-writing and intimate confessional documentary approach to our experience is a temporary madness and that stylistic acrobatics constitutes only one answer, an evasion of the difficulty. Ultimately there is

something in the human creature that wants and knows and needs illusion, a fiction, an art made of experience. That means storytelling.

How has your work been treated in general?

My best reviews, the most careful, detailed readings of my work, especially my last novel, came largely from young women and from midwestern men. My last novel, which dealt with the Depression, its survivors, and the beginnings of the Second World War, was most carefully reviewed by people who understand the locale and the break-up of that time in the world. People who aren't familiar with the era emphasize the protagonist as a modern heroine, while the other things I'm saying aren't dealt with. But I didn't get the attention I wanted or needed on that book, partly because of the tyranny of the *New York Times*, which didn't review it.

Why do you think the book wasn't reviewed in the Times?

It was partly the fault of the publishers. And partly it has to do with the huge spaces between my publications. It's the thing that's worked most against me, the time element, because I get good reviews when I get them. It had been a long time since I'd published a novel and I didn't fill it in with publication of short stories. So my name is not generally known. *Silent Voices* should have had much more attention in the press because it was the first book in this country on black women, and the reviews it did get were sensationally good.

Have you felt any sexism in the literary world?

Yes, I've felt some. Usually it's taken the form of a slight. As an example: I went to a party given by a writer friend. He had invited other writers and an editor. He introduced his guests to the editor as, this is so and so, the (male) novelist, this is so and

so else, the (male) novelist. He introduced me by saying, this is Jo Carson. Period. Well, I talked at length with the editor, who didn't know I was a writer until he asked me for a ride to his hotel. Suddenly we discovered that he was from Texas and I from Oklahoma and that we had a lot in common. We talked about the civil rights movement and I told him I was trying to get an advance on a book about the Southern Negro woman. And he said, "My god, I didn't know you were a writer." I told him that any voice that had been that untapped had a hell of a lot to say. And that I wanted to find out what that was. He said, "Well, write up a prospectus on it and send it to me." I did, and Delacorte wound up giving me an advance to go to the South! A rather fortuitous slight on the part of my male host, but nevertheless, a slight.

What are your greatest stumbling blocks as a writer?

Well, finding the uninterrupted and sufficiently long hours in which to work. As a fiction writer, getting started, and getting the right tone of voice. I wrote my second novel once completely, and then I tore it up and wrote it all over again, because the tone wasn't right. I'm working on a short novel now and I've written the opening thirty pages at least seven times. That's more than the length the whole novel will be!

You must want to tell that story.

I'm clearly tenacious, but my habits are not ideal. I work every morning that I can, but I'm too easily distracted. I tend to take on too much. I enjoy life too much. I was a very good animal in my youth, I lived very close to my body. I think that the need and desire to live has been my biggest problem as a writer, but I also think it has fed me. Poets have the advantage of completing a work within a given spasm of time, but a novel is a commitment of a couple of years, at the least. My first novel took me six months, but my second one was ten years in the making.

Another disadvantage to most American writers is the lack of a good community of writers. We're spread out. Most American artists face this to some extent, I think. I know many writers and artists but they are all over the country.

My lack of education is also a great stumbling block. I've read a great deal, I've studied randomly, but if you have a good education when you're young, then your adult mind can draw on what the brain has been asked to do in the way of ordering knowledge. I can structure a novel, but that's quite different from being able to process knowledge. If you have a mentor, if you can read with guidance when you're young, it's invaluable later.

Virginia Woolf complained of educational deprivation — that her brothers had enjoyed not only formal training but intellectual advantage. Is that what you're speaking of?

Well, one of the reasons I have written close to youth, and close to metaphor, close to primitive American sources, is that my intellectual life has been neglected in some areas. For instance, I've chosen to make the female protagonist in my new novel an art historian. There are so many things I feel I ought to know, and I don't mean little pieces of knowledge I can look up, but a mass of experience. I need to know a lot of what this educated, intelligent woman would know about. But a classical education is the rare privilege I needed and didn't have. I also think I should have read three times the fiction I have. One of the reasons I haven't is that I can't read a novel when I'm writing one.

Many novelists say that. Why?

Because I hear the rhythms of it, I hear the music of it, and I fear it will get into mine. While something is emerging from my unconscious, I don't want to experience someone else's struggle with the problems that concern me. I read all the time but not always fiction.

Is it as if you are protecting that very fragile realm you're tapping into?

Yes. Perhaps it's the same reason I didn't marry until I had made conscious what I was doing. I think you really have to be conscious of what you're doing before you have any control over it. Otherwise your control is primitive, creaturely, but not exactly mental. You can be surprised and damaged if you're not conscious.

Or you can sabotage yourself.

Yes, by emotional indulgence. My family did that. I also went to at least one movie a week for five years, when I was growing up, in which a woman like Bette Davis or Joan Crawford was emoting on the screen for all she was worth! And losing out usually. I believed that this was the way I should behave! It took me a long time to realize that that was their emotion, not mine.

How have you most sabotaged your own efforts?

By my earlier preoccupation with love affairs. Partly that. The anguish and joy. Although my talent for happiness usually overrode everything. I can't be sad for too long. My family's life was so tragic that mere sadness seems almost irrelevant to me. I experience great tragic sorrow, but chronic kinds of sadness seem shallow to me.

What saved you from the paths of self-destruction most of your family took?

Because they were alcoholics, I couldn't be! I also think I had a powerful sense of self-preservation, and a feeling of being totally responsible for my own body. It's been absolutely vital to me as a writer. As a child, I was very physical, good in gymnastics, ran track and beat the little boys because I was taller and had longer legs! I lived well with my body, I think.

Do you feel you've invented yourself, that given your background, you could have lived a different life?

The more you manufacture and fictionalize as an artist, the less easy it is to define yourself. I don't make strong distinctions between the life of my imagination and my actual experience. I think that my life, as I could quickly make it available, is a counter-construction over against a life that I couldn't afford to live. Over the life I might have lived if it hadn't been for the tragedy of my family. Who I was in the making, I'm not sure I know now. It's like someone who's had surgery and developed alternate muscle systems. I've developed a very complex other self, I've found many alternate routes that I've made deep because of the facts of my mother's life, which I know fed my own creative life. And I can say that there's no difference between my life and my writing life.

Did you ever want some demarcation?

No, but I have had a great nostalgia and wistful desires for giving it up at times, giving up writing for the sake of living with all my talent for enjoying life. I enjoy it anyway. I was taught to be a player. But I had to recognize my secret, driven ambition. I have no ambition for an abstract position or for fame, I have ambition only to do and be recognized for what I do best. For what I am.

Did you ever have the feeling, with this great love of action and living, that by choosing to be an artist you were missing out on something?

Yes, you are missing something when you choose to be an artist. *If* you choose it. I think you are or are not an artist and the choice lies only in recognizing it or not. But you have to decide that whatever it is that you're missing out on may not be of much value. You have to be sure of what you're gaining. It's so abstract, in a way, which is why it has to be built all the time, so

that it becomes a culture, a world that you can't resist any longer, a world so familiar to you that finally you not only can't resist it, you're accustomed to it and prefer it.

What do you think makes an artist, causes a person to build an internal culture apart from the rest of the world?

Well, I think and write about that from time to time, in a diary or somewhere, but really it is a mystery. I suppose one must have been obliged for survival to build a deep inner world early. And then I think it is likely that most artists have lived with a concrete fear of death, or sense of it, most of their lives. Terror. That's an ingredient. And then there is something slightly out of order which must be ordered in one's consciousness of the world or of the characters in one's first world. And there is of course the natural irrefutable vision of an idea—a form, a reassembling of things or an assembling of them in a clarifying way—that is probably present. The eye is dazzled and if one is not too self-preoccupied and yet left alone to make one's mudpies as a child, one comes upon a knowledge before a proper language has developed with which to deal with it, and the pursuit of it is on. The hunt is on for the way in which to make concrete that which one has stumbled upon while rummaging about the world on one's own. Physical freedom—that gave me a lot of knowledge of myself and nature somehow. A sense of the way things balance, of form, of my own limitations and talents for living in the physical world.

And the sense, deep and early, that one is slightly alien to the local society, an outsider. That's essential. But how all that comes about in one life? I don't know. Any nature is as difficult to explain as an artist's.

Suffering and terror and independence, loneliness, joy, lust for being alive—extremes, passionate feeling brought fully conscious. Some of that. And a love of puzzles and a visual affection for the world, the way the human creature gets around in it. . . . Well . . . I don't know, as you can see. I always felt I knew a secret. I'll never tell it but maybe that's why I'm driven to tell everything else, so I won't tell it.

Josephine Carson (b. 1919)

Novels

Drives My Green Age, Harper & Brothers, 1957
 (Published by Bompiani in Milan; published in England
 by Hutchinson & Sons)
First Man, Last Man, McGraw Hill, 1967
Where You Goin, Girlie?, Dial Press, 1975

Non-Fiction

Silent Voices—The Southern Negro Woman Today, Delacorte
 Press and Delta Books, 1969

Plays

Open Season
Sanctuary, produced by the University of the Pacific, 1978

Awards

1957, 1963 Huntington Hartford Foundation Residence
 Grant
1958, 1959 John Simon Guggenheim Memorial Award for
 Creative Fiction
1960 Dramatists Alliance Miles Anderson Award for Three
 Act Drama—for *Open Season*
1969, 1970, 1971 MacDowell Colony Residence Fellowships
1970, 1972, 1973 Yaddo Residence Fellowships

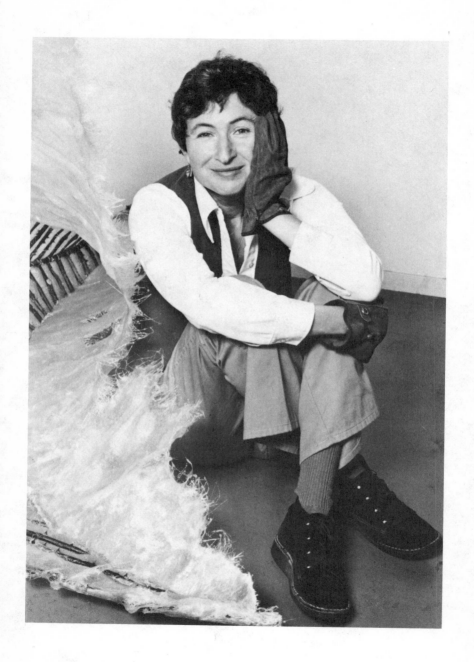

BELLA TABAK FELDMAN
Sculptor

Bronx-born Bella Feldman attended the High School of Music and Art in New York and took a B.A. at Queens College. After a twenty-year hiatus, during which time she taught and raised a family, she earned an M.A. from San Jose State University. Feldman is an assistant professor of sculpture at the California College of Arts and Crafts. She is married and has two children. In eighteen years, she has had as many one-woman shows, as well as numerous group exhibitions. But it was not until 1973 that Feldman's work began to reflect what she considers conscious intention. The sculpture of her "post-student" period displayed realistic metal casts of small animals such as rats and turtles. In a kind of evolution, Feldman explored her childhood interest in biology by fusing parts of animals onto other animals in bronze casts. She created what she termed a "museum of unnatural history," reminiscent of a medieval bestiary. For several years she has emphasized environments of her work rather than individual pieces. Her recent work reflects a more abstract vision and employs fiberglass and the fragile but resilient branches of rose bushes. Feldman's work is included in the permanent collections of the Oakland Museum and the University of California at Berkeley and in many private collections.

From conversations during December, 1977, and January, 1978.

87

You've made art for a long time and yet you maintain that you were a late bloomer, even though you had your first one-woman show when you were thirty.

I was a mother raising two children and looking after the house, a part-time teacher and a part-time artist. Only in my late thirties did I realize that all that dispersed activity added up to amateurism. I didn't realize what it meant to be truly serious about one's art in 1960. I really had a very prolonged student period. I would show occasionally but my work was derivative and my progress uneven.

What held you back from being serious earlier in your life?

I held myself back. But my isolation as an artist held me back also. I was functioning at a minimal level, keeping a toe in my art, but I didn't understand the kind of intensity, the kind of total focus that a serious artist gives to work. When my children became teenagers I was able to give my work the time and concentration I wanted to, and then, only then, I realized how diffuse the energy given to my sculpture had been previously. I had thought I'd been giving it my all. Indeed I had—all that was left after my domestic responsibilities. However, I had deluded myself regarding what I was accomplishing in this fractured way of working. No doubt I needed to delude myself in order to function at all. I wanted children and I wanted to be a first-rate artist. If I had felt that I needed to choose between these two desires, I'd have ended in the loony-bin.

Were you doing any art when you were young?

I went to the High School of Music and Art in New York. My family discouraged my being an artist. They supported me minimally through college, but that minimum depended on my majoring in something practical—a trade. So I became an education major. I didn't do art from the time I finished high school

until I was married . . . my husband was the one who encouraged me to begin again.

You got married at eighteen and you're still married to the same man?

Mmmmm . . . endurance and flexibility. My marriage has continued to change as my husband and I have changed, and we are each other's best friends despite our considerable differences in interests and temperament.

During those years of child rearing, did you want to become more involved in your art?

As I indicated before, I don't think I knew what I was missing. I would become interested in a certain artist and then I would make work that looked like that artist's work. It was a form of admiration. I wouldn't exactly copy, I'd just work in a similar vein. Students do that. There's nothing wrong with it, but I spent twenty years doing that sort of thing! I'm sure I wouldn't have if I had been able to focus.

How did you begin to focus?

When I was preparing for a show in 1966—my children were pretty independent by then—I could give it my full attention. As a result of this full attention I was able to see what my true interests in terms of form and psychological content really were. Things were quiet enough for me to be able to hear what the inner me was saying. I learned then that my interests as a sculptor lay in biological forms used toward provoking psychological as well as aesthetic response. The work for the show was a kind of free association on the theme of the egg. I'd never dealt with a single theme before . . . taking something to its conclusions. I'd also never understood before then what it was to take an idea to its full implications.

You've been called the Bella Abzug of the California College of Arts and Crafts. How did you acquire your reputation?

I had been teaching one class at CCAC for six years. Though I wasn't the most mature artist, I was a good teacher. I had good student ratings and thought I had a secure hold on my job. When my husband had the opportunity to go to East Africa in 1968, I obtained a leave of absence. When I returned in 1970, the school was burgeoning with students. A new chairman of my department was hired while I was away, and he was trying to fire me. It was somewhat heartening to know that his campaign to fire me began before he'd even met me. If he'd known me and was trying to fire me, I probably would have shrivelled up and given up. But he didn't know me, didn't even know my work. This enabled me to get angry and to fight for my job. The fight went on for a long time. I got to know and helped organize the women faculty members and students—because I saw my personal employment problems as a case of sexism, as did they. This made me more visible, and of course winning the fight made me more prominent still. It was a very character-forming two years for me. I don't regret it. It toughened me.

Did you at any point during the fight think you were getting fired because you weren't good enough?

I did at first, but when the chairman admitted that he didn't know my work, I had a rationale that prevented me from assuming that I was at fault. . . .

When a person is being chopped down by authority figures, it takes a strong, persistent ego not to fall into despair.

Part of what saved me was the endless work I had to do to save my job. I had to write briefs about myself, I had to go to the Fair Employment Practices Commission. A person can really fade under this, but I had the energy that anger sometimes brings. I had to holler, hey, everybody . . . it really is like going out and

getting votes for yourself. On the other hand I was very naïve. Had I gotten a lawyer I might have gotten it all settled in a couple of weeks rather than a couple of years—but then I'd have missed out on all that painful but useful toughening.

How did the struggle change you?

I became much more verbal and outspoken after the ordeal. I was very timid before, hesitant, self-conscious. I always used to worry whether people would like what I said . . .

So you attribute finally being able to stand up for yourself to having to fight for your job . . . as if one act of courage builds on another. . . .

I fought for my job out of desperation. I had been isolated all those years before I taught. I needed to teach, I needed colleagues. I felt desperately frightened of what would happen to me as an artist if I stopped teaching. Another motivation was needing the money to support the sculpture. I always felt I should support at least my own work.

How did the struggle for your job affect your work?

It took two years away from my productivity as an artist. But then, it changed my personality and no doubt contributed to my commitment to my work.

Do you remember other major occasions when you've been forced to reassess your commitment to art?

In 1973, I did a kind of "museum of unnatural history," with metal and resin casts of turtles and rats. An old friend of mine, the sculptor Manuel Neri, came to see this show. He liked it; he said, "It's about time you started doing some stuff." He was right. We'd gone to school together when we were both in our

early twenties and this show was in 1973! I was forty-three. It was the most solid work I'd shown till then.

How did that make you feel, when he said it was about time?

I felt pleased, of course. I realized I was beginning to hit my stride. I hadn't done it before. My friend was confirming what I already knew. Another occasion was going back to school to get an M.A. a few years ago. I thought I was just getting a piece of paper to cover my ass, to keep my job, because I felt I'd done the equivalent of graduate degrees many times over. But my teachers' on-call criticism was very useful to me . . . I developed very rapidly in my two years.

That must have been a turnabout for you as a veteran teacher, putting yourself on the receiving end of criticism. . . .

Yes, but it was good. I used the criticism. I think criticism is extremely valuable. I wish I'd had it sooner. I spent many years groping without feedback. Students have a right to take criticism and use it without feeling less original. No criticism tells you exactly how to resolve a problem . . . it still takes creativity to incorporate. Criticism merely points things out, that is if it's good. And if it's good, it brings about change a lot faster. The better the critical feedback one gets, the faster one can develop.

Even when you consider yourself a professional, developed artist?

Nobody's ever really developed . . . it's developing.

But there is a difference between where you are and where your students are, isn't there?

I think we're all in the process of trying to find the special thing that we have to say. I have more years in the struggle but that

doesn't mean that some of my students won't leap ahead of me. Even while people are still students, they frequently surpass their teachers!

That might be one test of a good teacher.

The test of a really good teacher is if the teacher can *allow* it to happen.

How do you respond to negative criticism, say, negative reviews of your work?

Well, I've had it happen. I always look at the reviewer . . . but it's painful even if I do know him and don't respect him. Just to see something negative about yourself in print is painful. It's hard for colleagues to criticize each other, even if they respect one another, for fear of hurting touchy egos. But I wish there were more of it. It's helpful even if painful.

Is it oftentimes a difference in sensibilities that prevents colleagues from criticizing one another?

No, I think it's the touchy egos. However, criticism that comes from a totally different sensibility isn't useful. I tend to have a catholic sensibility and taste, but my particular direction in terms of emotional and psychological content is hot. . . .

Hot, in the McLuhan sense of hot media?

Hot in the sense that the work is emotionally laden, emotionally provoking. Cool in the sense of being detached, intellectual . . . that may not be the right term, because I think the intellect is used to produce emotionally laden works. Anyway, I received a critique from a colleague who is interested in such cool, detached work, with no psychological or subconscious content. I considered his criticism of my work seriously and then rejected it finally because we have different sensibilities.

Have you ever felt your work misinterpreted by a critic who had a sensibility different from yours?

On occasion. Several years ago I did a series of pieces using metal casts of rats. One critic reviewed my work implying that I was using the rat as a symbolic phallus, which wasn't my intention. It happened to be exhibited at a "woman's" show. My work was reviewed as one of the many anti-male pieces. I thought of the rat as a laboratory animal, that is, a used and abused creature. When I gave birth the first time I felt used and abused . . . of course, it's done differently now, but in my day, when you were ready for labor, they would just clamp you down to the table. You couldn't move. It was as if you were being brought in to be tormented and tortured. When I finished the piece, I knew it was kind of how I felt when I was clamped to the table.

How did you feel when the critic pronounced the work as anti-male?

Helpless. I did another rat piece for my Masters' show . . . I put them in an environment, a circular room. I closed off the rest of the gallery so that people could only walk into my rat room. Because you could easily pick the rats up and walk off with one, I hired somebody to stay there, and had the person take notes on people's reactions. The range was enormous . . . a few people thought it was a sexist piece against males, a lot of people thought it was funny too. I didn't think I was making an anti-male statement. I rather like rats. There were no references in it to males or females; it was a mock nightmare in the tradition of Bosch. I guess it was a spoof of Bosch.

Perhaps it was just the times. . . . It's almost a cliche that every piece of art takes on sexual connotations which, in turn, have political implications. How do you deal with negative attitudes of people around you? It seems that when you make yourself public, you inadvertently make enemies you never intended to make. . . .

As I get older, I don't care so much about other people's opinions. I used to be driven up the wall to think that I had made an enemy! One's skin thickens with age.

Have you encountered specific kinds of hostility from male colleagues?

Yes, and I think it's when they're afraid of me. Here's a good example: I was at a graduate student's review, asking questions of the student. He was a painter who had suddenly decided to do sculpture. His form had a lot of crudeness, was very ill-thought out, undeveloped. Of the five male art teachers on the panel, four leaped at me in defense of this young man when I criticized him. The young male student remarked later that he thought the other men had been hostile. But I'd been quite comfortable and objective during the critique. I was making clear points about sculpture, which I know a lot about. And I felt that if these men took my remarks as threatening, the more fools they! Of course, I don't know why I didn't feel threatened by them, because a few years back I would have.

Was it because they were painters, not sculptors?

It's probably more because I was sure about my remarks and there are not a great many things I'm sure about. But these days when I'm sure, I sound very, very sure. When I was younger, even if I knew I was right, the very fact that I was being attacked would have been enough to make me wither inwardly and to shut up. That's no longer the case.

Women are often said to take criticism of their work or behavior as personal ego attacks. . . .

I think everyone does. Teaching, I haven't noticed that male students take criticism better than female students!

Bella Tabak Feldman 95

Is it possible to criticize someone's ideas without criticizing their person?

Sure. That is, you try, when giving a critique, to leave their character intact and only talk about specifics of the work. It's tricky, though, because frequently their form of expression does reflect their character.

I don't see how you separate the two.

You have to try, both as the giver and receiver of criticism. But sometimes you have to deal with the student's character as well. I had a student who was a very dependent person, always looking to be told, quoting her boyfriend *ad nauseam*. Her work went from bad to worse. I had to talk to her privately to try to encourage her to make decisions for herself, I had to get the teaching assistant to talk to her. We really had to talk about her character. For her final piece, she did something that was really ugly, but it was a big step for her: she dared to make a decision to make something ugly instead of forever trying to please someone else.

I know you consider yourself a feminist. How does your political stance affect your work?

The best work comes out of intense feeling, rather than doctrine. On the other hand, really good work has always come out of artists who are touched by their times, for example Picasso's *Guernica*. He was certainly politically conscious but not a political artist. And Ben Shahn . . . probably his finest series was the Sacco-Vanzetti paintings.

So you'd say that politics might inspire but doesn't necessarily dictate the work?

When politics, rather than intense feeling, consciously dictates the content of your work, I think you produce inferior work.

Also, there are different ways of being political—some of those ways are quite subtle. For instance, a lot of feminist visual artists make cultural statements with the materials they're working with and with the imagery. A young woman by the name of Dorothy Reid made a large churchlike tent environment out of strips of old sheet material. That, to me, is a political statement. The way in which she constructed her environment and the materials used made a political statement without being doctrinaire.

What other kinds of materials have women artists used in their work that you feel are implicit statements?

Eva Hesse worked in fragile materials. She worked in latex, knowing that latex disintegrates within five or ten years. Textile work has traditionally been the realm of women, with some exceptions. Women have been very courageous about using fiber and other fragile and short-lived materials, maybe because they didn't have the ego or pretensions about producing for eternity.

Like being used to baking a pie and watching it be devoured in five minutes?

That may be part of it. Also, trying to get yourself established as an artist can so drain you or distort you that you really have to get your kicks out of the making of the work. In that sense, if you're deeply involved in the making, in the discovery of an image, or in the process of the work, it doesn't really matter if it lasts. You're more concerned with the actual doing. I think, too, that the feminist movement gave women permission to use the materials they were familiar with.

Would you say that the use of fragile materials has been one influence of feminism in art?

Definitely. Miriam Schapiro at one time was trying to make it in a man's world, with very male, hard-edged imagery. Came the

feminist movement and she switched to images in and of cloth. In my own work, I have come to feel more comfortable doing very fragile pieces.

Do you think there are differences between male and female sensibilities? Can such an area as aesthetics be approached from a sexual politic? Do men and women approach art from different, and perhaps conflicting, aesthetic biases?

This is a difficult issue to deal with. June Wayne wrote an article, "The Male Artist as a Stereotypical Female," (*Art Journal*, Summer, 1973) in which she explains the heavy prejudice of male artists against female artists. Her analysis is that male artists are treated as females in the greater society . . . therefore they've constantly got to prove their masculinity. One of the ways they do this is to put women artists down.

The old scapegoat technique?

Yes. Another way this affected art was to determine which images are appropriate to art and which are not. That is, which sensibilities will produce good art and which won't. Mary Snowden, a colleague of mine at Arts & Crafts, is a painter, a good painter. Some years ago she was doing renderings of machine parts and getting quite a lot of positive critical acclaim for them. She was living on a farm and got interested in pigs and horses and started painting them with a great deal of originality. When she exhibited the paintings of animals, her reputation suffered. She was not considered tough any more.

Because the work shifted to domestic imagery?

I think so. Yes. And subsequently she's kept up this really strong domestic imagery. She's beginning to regain her popularity after several years because I think those domestic images are becoming more acceptable . . . interiors, chickens, toys . . . the casual disarray of intimate family life.

What is there really that makes a machine any tougher than a pig?

It's an arbitrary definition. Even the idea that an image has to be tough is prejudiced. I once had a male graduate student who felt obliged, against his own predilections, to do rather hard-edged, conceptual items, when really his instincts and character wanted to do glittery, romantic things. So I don't think that very many images are specifically female, just that the artifacts of roles have been thrust upon us. I think that women making so-called "female" images more acceptable in the art world have made it more acceptable for men to make those kinds of images too.

One important impulse that catalyzed the women's movement early on was the desire to feminize . . . a general feeling of the sixties, it seems. In what other ways have women feminized modern art since you became serious about your work?

Well, there's the New York movement which consists of purely decorative pattern painting, supposedly derived from the women's movement and women's art and traditional quilting. I was quite surprised to see an article on Peruvian textiles in *Art Forum*. It was the first time something like that appeared in an avant-garde journal of American art. . . . Crafts have always been separated from "fine art." The fact that pattern art has crossed over is an indication of the direction of what is now acceptable American art.

As a teacher and artist both, you're in touch with the latest movements. I take it that West Coast artists feel that New York is still the center?

Here on the West Coast, there is not so much in the way of movements . . . there's much more idiosyncrasy and imagination. The women are still struggling to get recognition. There is practically no market, there is little camaraderie, there are no bars to hang out in, things are very scattered in California. You

can be great here and no one knows you . . . which has advantages and obvious disadvantages.

Do you feel isolated?

I'm in a better position than most artists; I have a steady job. I feel somewhat isolated in my vision as an artist. My landlord is the sculptor Peter Voulkas. He looked at my work when I first moved into my studio and said, "Mmm . . . it's good to have an eccentric in the building."

What are some of your problems as an artist?

I used to constantly question my commitment. . . . I still question, particularly when I don't sell anything. I spend all this money being my own patron. I'd get into this mood where I'd wonder what the hell I'm doing it for.

What kept you going?

I *had* to keep continuing. I'd tell myself it was cheaper than seeing a psychiatrist.

Why do you say that?

I was conscious of the fact that it helped me keep my sanity. I do feel that I've gotten in touch with a part of myself I couldn't in any other way. I believe that making images out of the inner chaos diffuses the power of the unknown. Just as laughter dissolves fear.

What, in connection with your art, turns you back on yourself, back into the chaos?

Packing the pieces away, when I'm low, gets me lower. If I've had a dry period, I have the feeling that I might not have it in me to make a new piece. The fear of impotency, not being able

to create anew, is much scarier than not selling. Or not being appreciated. The kind of feeling that comes right after a show. But ultimately, the excitement of making something fresh picks me up again. That's a high that transcends anything else.

Bella Tabak Feldman (b. 1930)

Exhibitions

1961	Palace of the Legion of Honor, San Francisco, California
	Crocker Art Gallery, Sacramento, California
	Bolles Gallery, San Francisco
1963	Bolles Gallery, San Francisco
1965	Arleigh Gallery, San Francisno
	American Institute of Architects - California Conference
1967	Arleigh Gallery, San Francisco
1968	Philadelphia Art Alliance, Philadelphia, Pennsylvania
1970	Nommo Gallery, Kampala, Uganda
1972	Bolles Gallery, San Francisco
1973	San Jose State University, San Jose, California
1974	Berkeley Art Center, Berkeley, California
1975	University of California, Santa Barbara, California
	San Francisco Art Institute, California
	Gallerie Bernard Letu, Geneva, Switzerland
1976	Mills College, Oakland, California
	Dominican College, San Rafael, California
	Grapestake Gallery, San Francisco
1979	California State University, Hayward, California

Group Exhibitions

1964	San Francisco Museum
1972	"Bay Area Sculpture," College of Marin, California
1973	"First Sculpture Invitational," Palo Alto Cultural Center, California

1974	"Taboo Show," Womanspace, Los Angeles
	"Game Show," Both-Up Gallery, Berkeley
	"Surrealist Object," San Jose Museum, San Jose, California
1976	"Polymorphous Sculpture," Syntex Galley, Palo Alto
	Represented at Bologna Art Fair, Italy
	The Handmade Paper Object, Santa Barbara Museum, Traveling Exhibit
	The Multipte Image, Fine Arts Museums of San Francisco
1977	"3 Attitudes: Paper," Fiberworks, Berkeley
	"3 Sculptors," College of Marin, Kentfield, California
1979	"Death Show," Space Gallery, Los Angeles

Public Collections
University of California, Berkeley; Oakland Museum

Awards
E. L. Cabot Trust Fund of Harvard University for Research on East African Arts, 1975

Publications
"The So Cattle Sculpture of Uganda," Fall Issue: *AFRICAN ARTS*, University of California, Los Angeles, 1973 (Co-author with Dr. Ross Coates).

BOBBIE LOUISE HAWKINS
Writer

Bobbie Louise Hawkins was born in Abilene, Texas. For a brief time she attended the University of New Mexico and then studied art at the Slade Institute in London. She taught art in missionary schools in British Honduras; she attended a Jesuit university in Tokyo while acting on radio and stage. During her twenties and thirties, she thought of herself as primarily a visual artist, though her work was sporadic. She illustrated several books of poetry for Black Sparrow Press in Santa Barbara and had her first one-woman show of paintings and collages in 1974. Married to the poet Robert Creeley for eighteen years, she was surrounded by writers and literary people, and began to shift her artistic interests to writing during her early forties. For many years, she kept her writing private—woodshedding, as she calls it—until she felt her work was competent enough to make public. A long gestation period was broken for Hawkins when she settled in the small community of Bolinas, California, a heavily artist-populated environment which gave her writing a context in which to surface.

Hawkins has two published books of poetry and two books of short stories. Her stories deal with the manners and conventions of the family and relationships between family members. Many are written in the dialect of the Plains and Southwest, and spiced with the aphorisms and philosophic musings of farmers and other country folk. Hawkins also spends part of the year

From conversations during February and March, 1979.

touring in concert with singers Rosalie Sorrels and Terry Garthwaite.

She has taught at the Naropa Institute in Colorado and the New College in San Francisco. She has three daughters.

When I asked to interview you, you told me you had kept your writing private for many years. What did you mean by that?

I'm in favor of people keeping their writing to themselves for years.

Why? If you keep your writing to yourself, you might wind up like Emily Dickinson with only seven published poems in her whole life. . . .

It's more like Rilke; there's a formative period, when what you want is to arrive at an originality that isn't an invention of originality. I mean originality like origins: you want your thought to originate from your thought. Thought activates thought in the same way that writing activates writing. Real life activates art. It's also true that art activates art. Writers are people who have been readers, as painters are people who've looked at paintings.

Are you suggesting that a person who wants to make art might put herself through an apprenticeship?

Yes, the person to apprentice yourself to is yourself. Normally, when you begin anything, you're like Alice, you're floating in that enormity of ignorance and intent and the action is who or what swims past. You see no landmarks in sight. The beginning and the middle and the end are an enormous melange. You're incapable of discriminating because you're young in it.

Then you begin to arrive at discrimination?

There is a notion young people often have, that they're not going to read things for fear of an influence, during the time they're writing. You can achieve the same non-influence by reading voraciously and variously. Without noting it, you take the bits to yourself that are akin to your nature. Those bits are no longer derivative, they've become part of you. I do think that discrimination is natural. When you walk along and something catches your attention, you've got to stop and look at it because that has your name on it. Sometimes something catches your attention and you're pushed out of shape, for as long as it takes to absorb what's fascinating to you about it . . . and then you regain your perspective. But you're changed. Now when that happens to me, I very often feel a revulsion to the thing that's held me so fascinated, because I suddenly get far away from it. I've actually done some absorbing, but I've gotten bored.

You're talking about the quality of attention?

Yes. If you're paying attention to attention, one of the great luxuries you allow yourself is that you notice when you're bored. It's like watching small kids who make the eraser as specific as the pencil. You allow the fact of boredom as specifically as the fact of attention, and if something bores you, don't be there. I don't mean your boredom is always justified. A lot of the time something can bore you because it's out of sequence. You aren't ready for it.

What was something that once bored you and now holds your attention?

Henry James bored me for years! He was one of the writers I kept pushing myself on. I wanted to like Henry James because so many people I respected and cared for adored him. It was clear they were getting an experience from Henry James that I

couldn't. Every time I picked him up I thought he was dull, dry, and told me far more than I wanted to know.

When do writers tell you more than you want to know?

Well, everybody has a tedium threshold. When someone tells you more than your threshold is capable of hearing, you're bored. There's a Texas phrase for it . . . "I've enjoyed about as much of this as I can stand."

You sound as if you had already developed a judgment about what was necessary to keep private and what was good enough to make public . . . as if you already had a well-defined critical judgment of writing before you began to publish.

Musicians know it's dumb to go public when they can't keep the chord changes right. It's too apparent. They do what's called woodshedding: the solitary work necessary before you join other company. Writers tend to go public very fast. As soon as there's something on paper they'll hit an open reading with it, or involve their friends. It's as if they want the outside world to tell them whether what they're doing can pass. My personal inclination was and continues to be to achieve some level of expertise privately before I make it manifest. I can't bear being a blot on the landscape.

Do you feel you had a strong sense of yourself before you began to publish?

Well, that's one advantage in being a late bloomer. If you're involved with understanding yourself and put your energies there, then it stands to reason you're going to know something about yourself by the time you're my age. Not everybody wants to be that self-involved, and with good reason. For many, having that much of a sense of themselves would only prove destructive. Personally, I adore people who've opted for their own and gone for it. What they come up with originates in themselves as

they are in the world. That's the sense of originality I was talking about, not that superficial question of whether someone else has already done it. Williams says, "Culture is still/ the effect of cultivation/ to work with a thing/ until it be rare." That takes compulsion. I believe artists must be adequately compulsive. In the early times there aren't many rewards and you have to be compulsive to be bad for as long as it takes to get good. The ones who don't have an adequate compulsion, and had planned on its being easier than that . . . well, you know how many miserable faces you see accruing over the years. Then, as often as not, there's a grab for the luxury of disillusionment, that dumb mistake.

Is that what disillusionment is all about? The nostalgia that times used to be better and now the apocalypse is waiting on the doorstep?

I think disillusionment is what some people call how they've worked themselves into a deprived place. Life used to be more fun—and now it isn't—and what happened? What they decide is that they're past innocence—any feeling of joy and delight they had is gone. But often, they've covered themselves over with this stuff that isn't the stuff of their own nature, and their own nature is obscured. Their energy is going into carrying all that extra stuff. Their own nature is down in the bottom wondering where the light went.

You don't believe that, I gather. In one of your stories you said that pain is the least interesting part of it.

Well, there are always plenty of people who opt for comfort, instead of their own particularities. There's nothing wrong with that. Things are so fragmented these days that people who don't want to think and shouldn't have to are forced to think. They become incredibly distressed and neurotic, and the nightmare potential is one of those people who's led a normal life and then takes an arsenal of guns and shoots everyone in sight.

Assuming that you opt for your own particulars, what happens next?

Once you make that variant in your nature, that variant keeps you going at that angle, unless you choose to come to a dead stop.

What do you mean by a 'dead stop'?

I mean, you cut off all your input and you stop in a comfortable niche. Sometimes fear causes people to cut off.

But artists live in fear all the time. . . .

Yes, but the ability to live with fear is a part of the artist's condition. You realize that you're moving into something that looks progressively more lonely. And in fact you're right. The more particular you are, the lonelier you'll be. That fear of isolation can make a person choose not to make art.

How does the artist assuage the loneliness that is particular to making art?

You can deal with some aspect of it consciously, by increasing the richness of your input. When you're creating you're in an output situation and you can simply drain yourself and go around like a person with a vitamin deficiency, and wonder if this is what art requires, that you be this haggard, hollowed-out individual who's giving it all to art. Writers are enormously advantaged because books are almost always available. And if you remember that that was your original dope, reading, that you adore words and reading. . . .

But reading doesn't replace stimulating conversation. . . .

It's important to remember that as you grow more articulate, you're not always going to be in the midst of articulation that

feeds to your content, because you're going to be more developed than it is. You're just not going to find that many people who want to talk that much. So it's up to you to deal with it. Artists create themselves, out of themselves. There's a cannibalistic aspect to it. I think you probably know what I mean.

Yes, in some ways, this book is a validation of that.

You hate the necessary self-involvement. At times you're so fed up with yourself. Talk about woman as vessel. I tried to fill myself up. Since I wasn't educated, in the course of reading things that fascinated me, I'd read right through the things that I couldn't understand. And they'd continue to fascinate me!

Something like listening to opera in a foreign language?

Yes, I thought I should stop and look it up in the dictionary and all that business. I think at that point I was involved in a personal philosophy that allowed for my ignorance. I had to think of my mind as larger than my understanding. I would hit upon a new piece of information every so often and suddenly go click: I'd feel the geography adjust itself. And suddenly all kinds of things would become a unit for a while.

That's what I think of as insight! All the layers come to the fore when another bit is added . . . as if the bit is the catalyst that brings it all together.

Yes . . . it happens and then you've got it in your conscious mind.

Yes, there's a sense of the vessel being boundless. Reading and consuming information makes me feel as if there's no end to it. . . .

I believe there's no end to it. The fact of the organism is always going to be larger than your understanding of it. You can bring

everything to bear for as long as it takes you to understand as much of it as you can understand and it's *still* going to be larger than that!

You have spoken about the assimilation of information in general. What about the specific problem of absorbing the work of your contemporaries? It seems that if you participate in the external world, in poetry readings, et cetera, you have to endure long stretches of boredom in order to sort out what's true and rich for you.

I will endure those times to find something truely kindred to my nature. I'm willing to sit through long periods of time waiting for those moments when my being is suddenly elevated and swung along by somebody else's work and I forget myself.

That's a kind notion, hooking up with what's kindred to you.

Well, we go into the social world to be in company also. In terms of your own writing, when you're really trying to get into your own thought processes, it's the same thing as when you're living with someone. If you try to share it, it might get bounced. I once let a book get dissolved in the void. I made several poems out of the idea of the coerced voice. And I let a couple get printed. Then when I tried to create this book, every time I would come to one of those poems, it would have that weird shimmy of knowing somebody had liked it, or knowing that someone had criticized *this* line . . . so hard to read past a line when it's been handled . . . you know. I let the book dissolve because I became an enthusiast over the two larger poems. . . .

Do you think that was because of external manipulation or reinforcement that you really didn't need?

I think that was my first big lesson. I've been working on a long poem for about five years, intermittently. I've read from it but I

won't let anyone print pieces of it. . . . It's projected for more than a hundred pages and I've got about twenty done. I can't believe it. I'm frightened by it, so I back off it. It's frightening to me to take on something that large. I question my ability to hold something that large.

That may explain why you've chosen to write very short stories?

My inclination has always been to say it fast. I used to feel guilty. When I was working on pictures, I wouldn't paint anything for a period of months, and then suddenly in a period of two months I'd make thirty pieces. And then I'd feel guilty again. I mean, the final thing does or doesn't hold its size, but I bought that brainwash that a picture worked on for three years was inherently more valuable. That I could produce things so quickly and so in bulk made them suspect to me.

Yet there's all that gathering and leading up to the out-pour. . . . Is this one of your problems in writing?

When I started writing, my problem was, how in God's name can I write a hundred pages! Suddenly, I'd have told one major aspect of the thing in a paragraph! And I'd be looking at it and thinking, This is supposed to thread through a hundred pages! What I'm talking about is the process mind which goes for the totality. You tell everything at the highest level of energy you're capable of achieving. And that can be pretty fast. You see, for a while I thought a story had to be between five and seven pages to be real. I used Fielding Dawson and Richard Brautigan to validate that there's no such thing as a theme before you get there, and there's no such thing as a size.

The size thing seems to be an academic leftover, like, Teacher, how long does the paper have to be?

Exactly. Well, you know, any theory is adequate.

Isn't that what artists do? They make something and then develop the intent to justify the making?

In writing, you have to work on your allowance muscles; however *it* works is the *it* of it. You're going to do it that way, in order to find out what it is that you do. Because you don't really know what you do until you begin to have a panorama of what you do. The worst thing in the world is to have an attitude, prior to your doing, that influences the doing, so that what you see over and over is a reiteration of the attitude that you had before you began to do!

It's somewhat like investigating a problem while thinking you already know the answers. But what you're really talking about is some sort of intuitive trust in your abilities.

Yes. The writing is ahead of your thought. And you're the first reader of it. I read my work, loving Lawrence, Conrad, Dreiser, and suddenly I'm looking at what I just wrote and it's trash. I think, next to them, this doesn't hold up! That's a problem. But somehow, you've got to extricate yourself from what it was that made you a writer to begin with, namely that you adored reading or that you had heroes. Franz Kline once said that there was a point when he realized that his shapes, the ones that look like gigantic brush strokes, were his shapes, and it was an enormous disappointment to him. His heroes' shapes were in his mind and they were apparently not available to him. He didn't say that his were inferior, only that these are my shapes, and wow, I thought they'd be closer to where my taste is. But to accept that in yourself! That's something! When you have a breakthrough, very often you're not changing, you're suddenly noticing. Sometimes when you notice a form, it may mean you're just on the verge of changing.

Such as moving from one period to the next?

Yes, for instance, you notice that you're using a word a lot. Then you get tired of that word, now that you've begun to notice it!

You start looking for another word to take that word's place. Sometimes the noticing means something's come to your consciousness because you're ready to let it go.

How did you arrive at all this thinking about thinking and absorption?

What's brought me to it recently is that in the past couple of years I've been asked to give lectures at New College in San Francisco and at Naropa in Colorado. What I've done with those lectures, instead of going in and talking as if I were inherently correct, is make each one an occasion for me to think out loud. There's a different tempo when what's happening is speech. One kind of writing happens when I'm thinking about something and writing it down. But when I start talking through it, it's like sparking an engine. I can move around faster and say more various things, speaking them. So that was a breakthrough for me, realizing that. You can't let dead history weigh you down, the idea of the right way to do it. Apollinaire said that one cannot go about forever carrying the corpse of one's father.

When did you come to acknowledge to yourself that you were a writer, that you had the stuff and wanted to publish it?

When I was forty.

You were still living with Robert Creeley then. During that period of time, you were known as a visual artist . . .

When I was young, it was thought that I was going to become a painter.

Did you think of yourself as a painter?

Yes, for a time. I studied painting for a short time at the University of New Mexico and then for a year at the Slade in London

during my first marriage. I also did some acting, originally to get rid of my Texas accent. Part of my self-improvement program.

Were you serious about acting at any time?

I don't think so. I think my acting was part of that curious behavior that makes little girls stand in the middle of the room and recite. There's a predilection in Southern families toward encouraging the girls to perform. It's thought to be quite charming. When the girls grow up, they think that cute performance is the same as opting for art.

Were you painting during your twenties and thirties?

Well, every time I painted it was bad. The ones I can remember were romantic and imitative. By the time I divorced my first husband, I wasn't very actively painting anyway. I was just trying to make a living for me and my kids. I worked in an ad agency, then a television station. That just about ruined me. I started reading Kafka at the same time. To be doing something as abstract as selling television time and reading Kafka just about made me think I was gone crazy. I got it into my mind that the earth's crust might be very thin wherever I was going to put my next footstep.

Did you have any aspirations to become a great painter?

I had them, but my attitudes about myself were always high-flown. I lacked resources. The jobs I had to take required total attention and time and I hated them, so they exhausted me. When I wasn't working, I was with my kids. So I was being completely used up. My art began to float into the background as mistaken aspiration. I continued to be a dilletante at the things I wanted to do.

Is that the way you thought of your painting?

I thought of myself as a person who was hanging fire, who was having to deal with this practical aspect of my life, and I thought that perhaps sometime in the future there'd be another possibility. My mother's people are farmers, and none of them went beyond the fifth grade. And they're all very practical. There were times when my mother was working as a waitress and we'd have ten cents worth of cheese and a five-cent box of crackers and that'd be our food for the day. And I had rickets as a child. My history was very classic! When you've been that poor, it puts a level of fear in you and makes you very practical.

Why suddenly at age forty did you decide to become public about your art?

I think it's what happens to a lot of people when they're thirty. They realize that time is passing and they'd better get on with it. I didn't feel it when I was thirty. And according to the brainwash, it's downhill after forty. So I thought, if that's so, then I'm really in trouble because everything I'd done was still internalized, even though I had pages of it. This refers to the visual art work as much as to the writing. What I did was get together a folio of work and a book of poems. And I went to the city and got a piece of a show in a gallery.

Did you have to beat some doors down?

No, I just asked a gallery owner to look at my stuff. I overrode my fears about going out on a limb to be "considered."

How have you dealt with that?

I never had to with my visual art. The place where the work was happening was never confused in my mind with the showing. But with my writing, it was very hard for me, because I'm a process person. It's tough for me to drop the curtain and say, this is now finished and ready to be published.

Were you encouraged?

I think that Bolinas gave me a context in which I could surface. I got together with some other writers who brought work in progress.

How did you get published?

I got published by my friends. The work can't be peddled. Sometimes people come up to me after a reading and say they've been writing and have a hundred and fifty poems and want to publish a book, and how should they do it? I can immediately say I'm the last person to ask because I was a late bloomer and my friends found me.

But getting some recognition also feeds the ability to work. Are you saying that breaking out of obscurity comes naturally if you're any good?

If you get to be good, other people will promote you. It's like Ginsberg carrying Kerouac's unpublished book in his pack. The word spreads. By good, I don't mean you have to be a world-shaker. The ones who flash high are rare. Just getting to be so that you're a pleasure to read is rare.

You're a person who would obviously encourage a long gestation period in preparation for making art?

Yes. Just because you're capable of the experience of art doesn't mean you've already arrived. You muddy up your condition thinking that. A lot of bad work happens when people believe that as soon as they opt to be an artist, everything they do is art. The great thing you can do in pictures that's much harder to do in writing is to do the same thing over and over again, to draw the same image until you're finally so bored that your system refuses to tolerate it and finally says, oh my god, I'm not going to make that particular curve again. That's when you come up

with something new! When you stop feeling satisfied and start feeling nauseous and force yourself to come up with a new image. It's like that fairy tale in Grimm's, of the sister whose brothers were turned into swans. The sister was not allowed to speak for the length of time it would take her to haul in nettles and weave them into fabric and make the fabric into coats for her brothers. When she had made seven of these coats, she could speak. That's the mythic time required to let what's supposed to, come true. That time exists mythically within yourself, with you as your own protagonist. And you will not be good until you are. Enroute to it, you will be unevenly good. And that's what sustains you. You simply have to develop, and there aren't any shortcuts. Whitehead speaks of *Duration* as an attribute of importance, that a thing lasts as long as it must to be important.

Given the historical circumstances of women, do you think it's harder or different for women to live with the uneven-ness, the insecurities of making art?

I think the thing that's hardest for women is marriage and children. I think that small children demand and deserve a lot of time. Some women can take that on and sail through it. But most women get bogged into domestic circumstances. Usually it's the woman who has the work of the children. There's satis-faction and pleasure having children too. The question is one of time. A woman who wants to be an artist should seriously ques-tion traditional domestic relationships.

What about the woman who wants to stay in a family situation?

Then she's making a very particular choice. By the time she's breast-feeding a baby she's within that choice. Choices are real. Most people don't get more than one big one. Those big deci-sions get made really young. Most women aren't ready for the world then, and they solve it by going for a man who's chosen a piece of the world they agree with. So she's the wife and he's the

artist. They get to be in their thirties and he's put in enough time to be producing something that actually has value in the world. At this point she begins to want to develop other aspects of her nature. Suppose that he tries to change, to do domestic things that keep him from doing whatever it is that he does well and that's already defined. What she's doing is equivalent to a kid taking ballet lessons because maybe some day she'll become a great dancer. This syndrome creates a lot of buffoonery. There's got to be, earlier on, a larger overall notion of what the possibilities are.

But who knows how much she can develop, given the chance?

The question is not whether the woman doesn't deserve to get on with it. The question is, if she's with somebody who's actually arrived at an advanced level, should that be sacrificed? But to hold it against him, that she spent the time raising kids, is trashy. She made a real choice. You know, the Hopi say we're in the Fourth World. World of turning. In the Fourth World, no matter what you *deserve*, you're only gonna get what you're capable of asking for. You have to be able somehow to create the concept of your desires. My sense is that you can only do that one at a time, by yourself.

Then women have to create a social structure that allows them to get on with their stuff—a pretty big order, considering that there aren't too many models to go on.

Models don't solve it. As soon as you know you *require* something, it's up to you to get it. Nobody is going to give it to you. Nobody's going to give it to men either. If you know what your needs are, you're already lucky. If you don't go fill them, but choose to describe that lack as some social disorder, you're begging the issue.

But isn't that part of the problem for many women? That they haven't known their needs, that the knowing has been blurred and unclear?

That's a human problem. Everybody has it. Everybody has to learn to identify their needs. Nobody's going to come along and give you what you didn't know you needed. Women have been shoved into domesticity and men have been shoved into the world. Neither of those shoves is any good to you if what you're going to be is an artist. To be an artist is to be singular. For a woman who wants to be an artist, getting out of the house is just one more thing to learn.

Do you think women, in general, write differently than men?

I don't know. I think the artist defines the art. I think everybody writes differently from everybody.

But as a whole, given the female experience of childbearing, and so forth. . . .

That's only experience. Sure, experience is everything. But if you weren't having those experiences, you'd be having others. The important thing is to stay away from righteous dogma or blame. You can think in dogma forever. The dilemma with dogma is that you have to stay still for it. Sarah Bernhardt's motto was "in spite of".

So for you, experience is like an excuse, if you use it to apologize for your deficiencies?

My feeling is that you're going to be a bad writer until you're a good one anyway. If you start filling in the slack with descriptions of why you're not what you want to be it's going to take you longer to get better. And meantime, you'll get bitter!

Bobbie Louise Hawkins 121

Bolinas is known as something of an "artists' colony." Is that why you choose to live there?

One reason I live in Bolinas is that I don't have to explain myself here. I've been in this community for eight years and I don't have to go through preliminaries with people here. I don't have to deal with talking to a man and a woman and when it's her turn to talk, she looks at him and he talks. I don't have to wonder if a guy is misinterpreting my natural intensity as a come-on.

Do you have these problems when you're traveling?

I have that kind of problem, the question of being misunderstood, whenever I'm with strangers. I'm inclined to be hard on myself. That makes it hard for me to be in unsympathetic company because I believe it. As soon as somebody starts questioning me in their mind and I get that subliminal reflection, as soon as somebody has a negative attitude toward me, I'll believe it. If somebody gives me a compliment, I'll think it's because they're feeling good that day.

You don't seem nervous, you seem so self-possessed. . . .

A part of that is staying in places where I feel secure. If I go out into the world, it's with a definition already laid onto me, even a partial definition as a poet. But the partial definition lets me off the hook. You see, when I live my daily day, my friends, or at least many of them, are present here. I like getting adjacent to people in a daily way. Another thing is that I can get flashy in Bolinas, do a performance, and the next day it just fades back into ordinary life. People come up after a performance and they tell you how great you are and the next day you wake up and it's just you again. I can get back into normal goods immediately.

Doesn't a small town make you feel claustrophobic?

Not really. You see, a point that Paul Valéry makes is that as

artists get progressively more defined in their work, they get further and further out on a limb. That's why I think it's essential to pay particular thought to what your daily goods are going to be. Especially in my case, I need to be around a small group of people, since I don't live with my family anymore.

What are some of your stumbling blocks as a writer?

I'm bad at structuring my daily life. That's something new to me because when the kids were around, they got me out of bed and through breakfast and that started the structure of the day. Also I tend to constellate. I can easily be enticed into doing stuff that isn't writing.

Do you experience cycles when you can't work?

Oh yes. I go way up and way down. Those cyclical states of despair come back on you whether you're producing anything or not, whether you're being an artist or not. It happens to everybody. I get into one of those downs when I'm too depressed to make the kind of move to get out. Then there will be a point where I have the thought, I'd feel better if I got up and played my guitar. Of course, remembering you can help yourself is the first step up. You've already made the turn.

Did you experience cycles like that when you were living with your family?

Sure. In the family circumstance those cycles get battered back and forth. The cycles of the people around you bounce off one another. Sometimes it's a help, sometimes it puts you downhill.

How did you come to go on the road with your work?

Well, I like to perform. There was a point about two years ago when I wanted to be more active. I knew that if I left it up to somebody else to invite me to do something, it would never be

quite the way I wanted it. I wanted to travel, so I thought about who would I particularly like to travel with. The first thing I thought was that I didn't want to be the only one who knew how to cook and be effective. I wanted to travel with women who had some level of expertise, who if there was a car crash and everybody but one person was disabled, that one person could deal with it. Terry Garthwaite and Rosalie Sorrels are perfect. They're experienced performers and competent individuals, and they're great as friends.

Do you feel that performance and touring is the direction in which you'll be moving with your work in the future?

Performance is an ideal way to deal with the problem of not having many personal relationships. A dilemma when you're not having relationships in depth is that you don't ever get to do all of it, you don't get used up enough, you don't get to really spring it, you know. I get to come out on stage and just pour everthing I can think of into it. As powerfully as I can. And then I walk away, and I haven't made a twenty-year commitment! And I get used up.

How has performing and touring affected your writing?

I don't know that it's having an effect on my writing, but it gives me a more interesting life!

Bobbie Louise Hawkins (b. 1930)

Books
Own Your Body, Black Sparrow Press, Santa Barbara,
 California, 1973
Fifteen Poems, Arif Press, Berkeley, 1973

Frenchy and Cuban Pete, Tombouctou, Bolinas, California, 1977
Back to Texas, Bearhug Books, Berkeley, California, 1977

CHERRY JACKSON
Playwright

Cherry Jackson was born and raised in Harlem. After serving as the athletic director of a Harlem community center, and as a physical education coach in the Peace Corps in Africa, Jackson took a B.S. in Physical Education from UCLA and an M.A. from Mills College. She taught physical education in the Oakland Public Schools until, at age thirty-five, she gave it all up to write. Her first stage play, "In the Master's House There Are Many Mansions," was produced by the Black Repertory Theatre in Berkeley in 1977. The play deals symbolically with the issue of power struggles between blacks and whites. A second play, a collaborative work called "Worry Beads," was also produced by the Black Repertory Theatre in 1979. Jackson, still an avid athlete, runs track, skis, and does deep-sea diving: she has logged more than two thousand hours at the bottom of the ocean. She is currently working on short stories and plays for television.

What do you think kept you from taking your writing seriously before you were thirty-five?

It took me the longest time to get into my own womanhood and live with it. And I didn't do it until I met real women whom I

From conversations during January and February, 1978.

could admire. You know, there are parts of you that don't grow unless you get what you need. I mean, the grass doesn't grow until the rain comes. You need certain things to help you out of adolescence, into womanhood, into maturity. And you're always looking at women, whether you know it or not, because that's what you are.

How do you feel this has been a specific problem for the young black woman?

It's been a problem for all women, but black women had less choice of whom to look at. Women like my mother went to work in somebody else's kitchen, restaurant, doing whatever menial jobs black women were allowed to do. Even college-educated black women didn't have many options other than the helping professions.

You were a teacher and you worked in other "helping" professions.

When I was growing up, there was no path articulated for me. My family lived in a slum as far as exposure and opportunity are concerned. Mostly if you live in Harlem or Brooklyn, everything is finished—not only finished but they begin to put salt on it! But they'd done a very good job on me in school. I did what I was told to do, I was a good kid, a passive person, aspiring to middle-class stuff. My athletic energy kept me out of trouble with dope and getting beat up.

Did your parents make a distinction between what you could do and what your brothers could do?

The usual distinction, that boys are preferable. I was small and obedient so I never got the brunt of anything. I wasn't programmed or slated to do anything. I know my parents weren't in a place to plan for their kids. About the only thing I heard my father say about me was that he wanted his daughter to grow up

and learn how to cook biscuits and iron somebody's white shirts the way my mother had done. . . .

Did you ever write about your family directly?

Earlier. In my poetry. I wrote about things that bothered me because I had to, not because I thought of myself as a poet. Interestingly enough, I'm coming to an end of my poetry, the more I get serious about fiction.

In what I've read of your work, you use a male persona. Any particular reason?

I don't know women. I'm just now beginning to know women. All the big influences in my life until I was twenty were men. When I was a kid, I was always with boys, shooting marbles. I was thirteen before I stopped wrestling—and I only stopped because they wouldn't let me any more. I never read anything by a woman when I was growing up. I don't even own many books by women. And if I started at this moment trying to portray the black woman I still wouldn't have enough time in my own life to do it properly. It is difficult to treat black women because of our history and because of our men.

How do you feel the black woman has been treated in the scant literature and art she's appeared in?

Well, there's the ambivalence that exists. For a start, she's not posed in relation to her man, she's rarely posed in relation to anyone. Instead, remember D. W. Griffith's "Birth of a Nation?" Griffith created one of the first images on the screen of the black man chasing the white woman. Since white women were the standard of beauty, the brainwashing was pretty thorough— enough so to get the black woman to dislike herself. I can remember nigger-bleach days, something you put on your skin to make yourself lighter. Black is beautiful just arrived, you know. The black man has always fantasized beauty as the in-

accessible white woman. This created a big problem for black women.

Is that part of the black woman's reluctance to identify with feminism? That the movement is a luxury of the white woman?

That's part of the dilemma. The black woman has always had access to certain jobs because black women were less of a threat to whites. Now, if I feel I am denying my man something that he deserves and I'm getting, we have confusion and tension. For years, our concerns have been around how we're gonna get our freedom or the vote. Historically it's been that once black people start something—the vote, for instance—the white woman follows. Some blacks see that as a kind of co-opting.

As with civil rights and then the women's movement following quickly behind?

Yes. The women's movement took attention away from us. On top of that, people were just starting to get interested in ecology. Not that the causes weren't just. But many black women feel that we don't have enough energy to carry the white woman. I can't come out and get activist about the white woman, when essentially what she's saying is that she's tired of her husband oppressing her. My priorities are so much farther up the line.

But isn't the connection between white women and black women apparent, in that metaphorically speaking those same white women's husbands were oppressing blacks as well?

There's a difference between saying to your husband, well, I want more freedom, and saying I need a job to buy a loaf of bread.

You're talking about survival. But the women's movement is also involved with psychological levels of oppression.

The thing that I like about a fact is that whether people admit it or not, it exists. The fact is that women have discovered that they are human beings, whether they are black *or* white. When white women started thinking of themselves as niggers, it was the best thing that could've happened to them. Because that's the issue: power.

I did an article once called "The Black Woman as Nigger in the Black Studies Department." Which was *me* in the Black Studies department where they all talked about men. In that sense, color isn't important. We've all been divided and we fight each other because of our powerlessness. When it was okay to oppress black people, whites were kept from recognizing their own powerlessness. I dive a lot. There's a place I go to in Santa Barbara where some oil company came in and said they were going to put these big tanker monsters off the coast. And the people said, the hell you are. But if you drive down the coast today, you'll find that those same people were treated just like niggers. When the money came in, the corporate structure did what it wanted to do. Look, it's the same on all fronts. Look at the Bakke case. Both men wanted to be doctors . . . that's the important issue. The pill-pushing plumbers of the AMA make decent health care impossible for the unwashed millions of us. With the need for doctors in the country why should any person who wants to serve be denied?

Perhaps political "consciousness" didn't take us far enough. Do you experience sexism and racism still, even now when they're unfashionable?

Figuratively speaking, the racial issue is like a dead rat caught in the throat of the entire country, one which we can neither digest nor throw up. It's festering and stinking there, and its stench continues to stultify the generations.

Listen, there are those people who'll have you to dinner but not vote for fair housing. At UCLA, the women were moving and the men were sitting around complaining, oh, I can't buy you lunch anymore, well what can I do for you; you gonna

proposition me before I proposition you? Those guys didn't know *what* to do. Their role had been removed from them and they hadn't picked up another. A friend of mine said to me, I went to bed with my wife and woke up with a woman. Pretty surprised he was.

Have you experienced this surprise from black men?

No. I frighten black men away, in general, because I don't deal with them sexually. Women have all kinds of ways of dropping handkerchiefs and I never do any of those things. You see, because of our position in history, black women have very seldom been in a position to deal from power, so it's all a kind of sexual thing you do with each other. It's difficult to grow up in this culture dealing outside of the vaginal politic.

And that crosses color lines. Don't you think that things are changing between men and women as women come into their own humanity?

It has to change. Look, it's like being black, once you know you're whole, there's nothing anybody can do to fracture you again. We can't follow the old models or we'll meet the same disasters.

As with women mimicking men? There's a safe brand of "equal opportunity" advocate that says that women should be generals in the army if they want and men should train for careers as typists. I think that's missing the point . . .

Ah yes, now we see black people in the same jobs that were shitty with white people in them. But you know, the exciting thing that gives me hope is that women can create new forms, new jobs. And the great thing about writing is that you can cross all kinds of boundaries, sexual and otherwise. A writer sees in a way that distinguishes appearance from reality—appearance in the sense that the ordinary person sees things and is often struck

with what they see. I have faith, you know, so that I can sit here relatively alone and not blow my brains out at what I sometimes see. Once I was very, very angry. . . .

Were you involved in civil rights activism in the sixties?

I sure was. I was involved in the philosophy of Martin Luther King and Gandhi, which said you subdued all your anger and hostility if somebody spat at you. When four of us sat down at a counter in Atlanta and a white guy threw a bowl of soup in my face—I was shaking and subduing.

Were you affiliated with the Panthers?

No. By the time I got to UCLA the Panthers had been blown apart by the CIA. But there was plenty to be angry about there. There were all these old World War II colonels teaching in the physical education department. One day I was walking across campus and I thought, I've never seen a black face behind the podium the whole time I've been here. In my history class, I never heard of anybody except Jackie Robinson. I got fed up and went to the chairman's office and I said, Chairman, how come there are no black people on this faculty? And he said, well, we don't have any openings. At least he didn't say there are no qualified ones. I had thought of getting him and two or three other professors, those anti-life dogs, in the toilet and threatening them just to get the publicity, and saying, you have got to change your ways!

But you didn't get those professors?

No. But I was getting pretty angry. This is the only country that teaches you you're equal and shows you you're not. The whole thrust of my education at UCLA was designed to show me contempt for myself.

I remember freshman English, the great sifting pot of the university, thirty of us sitting there shaking scared. The teacher

comes into the room and scribbles something on the board that says, write me three paragraphs concerning one of these historical figures: Benjamin Franklin, Abraham Lincoln, and somebody else. Now this was when I was in my real *black* period. I took Lincoln. The teacher had these little subtitles under each name that he wanted you to deal with, like reconstruction, freed the slaves, etc. So I wrote down, Lincoln ain't never did nothing for black folks and if he did, I ain't heard nothing 'bout it and I don't know nothing 'bout it. And I signed my name to my paper. The next day the teacher said, Cherry Jackson, I'd like to see you at the end of class. And so at the end of class, the teacher said, this is a basic English class and if you want to stay in it, I would advise you to write English. Well, I swallowed all my piss and vinegar and said okay.

You went to college when you were in your late twenties. What were you doing before that?

I worked and then I was in the Peace Corps.

How did you come to join the Peace Corps?

When you're in Harlem and when you live on the fourth floor of a tenement house at 135th Street and 8th Avenue and at night you have to walk over junkies going upstairs and in the morning you have to walk over them coming downstairs and people are coming up to you saying, I got to have this fix . . . there's a kind of desperation, you want to get out, you wonder what the hell you're doing there and what is it that you want to do. One of the things that hastened my departure was somebody breaking into my house twice on the same day. I had a police lock and a steel rod that went down to the floor and they just took the whole thing off the door. So I signed up to go to Africa. I wound up in Monrovia, on the Western coast.

I've heard stories of Jews going to Israel and not being able to relate to Israeli life, discovering how American they really are. . . .

Well, it's different for blacks. I was searching for origins. I saw my mother's face and my father's face and it shocked me and I knew racially and tribally I was in the right place. When you go to Africa, you understand that you are in the arms of Mother Earth. When I saw the land in Africa, I knew there was something perfect and untouched.

You didn't experience culture shock?

Once you've been technologically oriented, you have to claw off your ethnocentric nuances in order to appreciate a non-technological culture. As long as I kept my mouth closed, people didn't know I was any different. Spiritually, I knew where my homeland was. I had no problem with culture shock when I was there, but it happened when I came home. It actually radicalized me, looking at my country after having another perspective for a few years.

Is that when you broke the obedience chain you described you were hooked to in your childhood?

Look, if you grow up with a certain moral code and you break it, it causes you a lot of anxiety and pain. It didn't happen overnight. I had to question why it was I was following the code in the first place. I don't know any single thing that made me break the code. But at some point I became aware that I had the power to make observations about what went on around me. And I saw the contradictions of what had been taught me. What got me to realize that the early bird doesn't necessarily get the worm, I don't know.

How did you decide to say no to teaching, after you'd worked so hard to make a career for yourself?

I can only tell you in retrospective observation. Whatever I got involved in, I always did a good job. Administrators love that kind of thing and they push you and give you certificates for

accomplishment. Listen, when they find a good nigger, you can do anything you want, you know, because there are a lot of black people who are angrier than I was and don't deal with the schools at all. But somewhere along the line I observed I was always fulfilling other people's notions of what I should do. When you get strokes, it's even more difficult to know what you really want, whether it's your idea or theirs. I had a lot of success teaching and I knew I was good and energetic, but I also wanted to write and never had the time. I might as well have brought my students home with me, they were dancing around in my head all night. And there were the kids in the Oakland schools, mostly being broken up by the system. I couldn't see any hope for it.

Did you write when you were younger?

I did but it wasn't serious. I *knew* I wanted to write when I was out of high school but there was nothing there to encourage it and I sure didn't know any writers. I had this frozen-ass English teacher in high school and I loved to write poetry. I wrote a poem about this tree, it had all kinds of human emotions, but when the teacher gave me the paper back she said, "You *never* describe trees that way, with human characteristics."

Didn't she know about personification? What did you do?

I kept that poem somewhere and hid it. I've always had a healthy ego. Besides, poets don't take criticism well. One editor told me to change a tense in one of my poems. She was a grammarian. The poem said exactly what I wanted to say. I didn't publish it.

Would you feel the same about a prose work?

With prose, I'll revise all day and bury the ashes. I took a fiction writing class; I went to my teacher with eight pages and he said

tear up seven. I took the criticism. I guess I won't do it with my poems because they come from my gut. My fiction comes from my heart and my brain. Which is why I said, I'm getting rid of the demons and don't need to write poetry anymore.

You said you have a healthy ego. Does that come from competing in sports?

I think so. In sports, I very seldom lost or got rejected. Of course, I knew when I started writing, I'd get rejection thrown in my face a lot of the time. But I'm not afraid of competition. Once a woman produces something that people can see, once she can bid and compete, she has ammunition.

So you think that women should be taught to compete more?

In sports, we'd always say of a weak team, no competition. But you know, I don't mean that women have to learn to compete with men. When a woman comes on the scene with some authority, she's got the ammunition she needs to do what she wants to. I don't worry about competition. I'm just beginning. It's enough that I had to make this decision that writing was going to be my life. I don't like other people setting a pace for me. I'm in no hurry. Anyway, once you hit your center, whether it's a fight or not is irrelevant.

Since you just began to take your writing seriously, how have you managed to support yourself?

I work at an outside job for stretches, say a year, a year and a half, save enough money, and take off to write full-time. When I'm working at a job, I have very little time to give to my own work. Every now and then, I *have* to do my own work, because the impulse is so strong. It's that drive that makes me know that I have to eventually quit the job and do my own work or otherwise I die. You see, I had a successful career, in terms of money.

Cherry Jackson 137

I knew that I had to get back to writing because nothing else would satisfy me. Once that was clear, I didn't have many alternatives.

This has developed into a pattern for you, write for a year, work at a job for a year? How has the interruption affected your writing?

It makes it hard for me to get the full volume of a piece of writing. There are three books that I should have written a long time ago. The characters are half developed. With a play, if you have to go away from your work for a long time, when you come back, you have a different mind set, your characters are different, your scenes unfold differently. I sat down with a play that took me so long to do that it turned out completely different from my original idea. Now that's not so bad, it might have happened anyway if I'd been working on it steadily, but the break made me lose a lot of what I had in mind.

When do you write?

Mostly my best writing happens between four in the morning until two in the afternoon. That comes from my athletic training —by habit, I'm more alert during those hours. I actually have to go through a routine before I can start writing. I look at the typewriter, then I push it aside, then I get a pad of paper, then I put my elbows on the table, then I lean on my elbows. Sometimes I just sit there and clean my nails! That's when I know I've sat down too quickly and can't write anything yet. But very seldom can I jump out of bed and jump into working. I have to browse around in my mind. Sometimes I just linger in that state between dreaming and sleeping and waking. When an idea keeps coming back, that's when I know I've got to do the work on it.

What does writing do for you?

It frustrates me, it makes me happy, it saddens me, it exhilarates me. The things I write about aren't themes that make me happy —the content of my writing disturbs me, but the writing itself fulfills something basic in me.

Do you feel obsessed by writing?

I don't know if obsession is the right word. I feel compelled. I *must* do my work. If that's an obsession, I guess I'm obsessed.

Could you give it up?

No, Never. Even though I think that the impulse to write is a plague. Because it drives you and you can't be happy unless you're doing it.

What are your greatest stumbling blocks?

Discipline. Organization. Setting goals. Starting. I avoid starting as long as I can. I do everything except write, I rearrange everything around me, and finally when there's nothing else to do, I sit down. The most frightening part is facing it. Ultimately you succeed or fail in your own interpretation of what you write. You have to make a leap off the curb without knowing what's around the corner. And I guess my limitations are my greatest stumbling blocks. I want to say what I mean, which presupposes that honesty is involved.

What do you mean by honesty?

Dealing with things that frighten me to think about. Emotional honesty. Getting that into the writing.

What do you need to be able to continue your writing?

Time and freedom. But the imperative thing is a sense of conviction about doing the work.

Cherry Jackson 139

Your commitment to writing solidified after your first stage play was successfully produced twice. How did you come to write for the theatre?

That play was the toughest thing to do and it took me a year to do it. I wrote it when I was still teaching. It came out of something I saw. I was on my bicycle peddling by the Solid Rock Baptist Church in the Fillmore. All these people were standing in line on the street, black folk, white folk, Chinese; and I said, I know I haven't been to church in a long time, but I know it didn't get so good that people are waiting to get in in the middle of the week. I saw a guard standing in the church, holding a big gun. I said, what's happening? And he said, people are lining up for food stamps. I had this premonition that somebody was going to get it in that church. About six weeks later a friend told me a guy had been shot there. I became really emotional. I had to do something about it. I didn't know what form it would take but I had to decide which medium I was going to use to express my anger. Was I going to do an essay or a play or what? So the play came out of my feeling that legitimate theatre is one of the loudest mouths in the community. And I was dealing with the problem of church and state, where the church is the last black bastion that white people can't corrupt but somehow have done it . . . how people sell themselves and rip each other off with dope and prostitution . . . I was dealing with a whole lot of things as a new writer, all in a one-act play.

You also wrote the play with a lot of black dialect.

Yeah. That's something I never want to do again. There's a difference between dialect and street talk. If you walk down Fillmore Street you will hear a particular black tone to the language, but it's in the rhythm and the selection of vocabulary. It isn't dialect the way Dunbar or Langston Hughes did it . . . like "go 'way and quit dat noise, Miss Lucy." Well, most black people on the street can't read dialect. It's just for effect on the page. It's like science having to create a language to describe

"laser," because there's nothing that exists yet to describe it, or how Chinese books use English words to describe certain technological items totally new to their culture.

Do you feel you have to talk differently around white people?

I talk pretty much the same all the time. Sometimes black people will get into old vernacular street talk, doing what they call niggerese, when they want to lord it over somebody who might not know what they're talking about. If I wanted to do another stage play, I'd use street talk. It's so succinct. One of the things that black people have not had the leisure time to do is become euphemistic!

In your writing, do you have problems capturing the particular rhythm that black people speak with?

Sure. English is not quite the language of black people. When you listen to a person on the street, it's sometimes a strain to get it down on the page. Written English puts limitations on expressing gesture and eyebrow-raising and all those body movements. And I don't want to whitewash street talk in my writing. I mean, we've got to clean up our act in order to get those jobs we're supposed to get, but we have to be careful not to lose our language.

You're working on television plays now. Won't you have to whitewash your language for TV?

I've been working on plays for cable television, where you are allowed to be an adult writer and talk about adult themes. Sure, I can tell a story without using a four-letter word, but sometimes I feel like using some of the obscenity I see inherent in something. An obscene situation calls for obscene language. I'm not

going to say, I grew up in the "inner city." Shit, I grew up on the reservation!

Why have you chosen TV as a medium?

Television is a challenge to me, a whole technology I can work with. I'm just learning the tools. People are tired of the pablum they get. There's nothing real on commercial TV. When I first started looking at TV as a tool, to see how scenes are made, where the drama is, how commercials are treated, how old people, women are treated, I couldn't believe it. When I look at Norman Lear's shit, why he's the only guy I know who can put five or six black male characters on one set and all together they won't equal one black man. And I'm not talking about super-nigger or Uncle Tom, just an ordinary black man.

Aren't black writers creating black characters for television?

Maybe now more than ten years ago. But it's so difficult to get into a writing stable as a paid staff writer, that once you get in, you don't rock the boat. One of the things that black people are famous for is holding those blacks who are in positions of power responsible for the whole race. A black person will get a position. When he starts selling out, other black people are enraged. But if that person doesn't compromise, he'll be on the streets. Writers who are paid to perform are in the same bind.

Earlier we talked about why you've so far used only a black male persona in your writing. Do you have any plans to explore female characters?

I'm reserving my commencement with women in fiction. I'm preparing myself. When I present my women, they will not be weak or pleasing. They will have accepted their womanhood as being as good as anything else. They will be active, doing people. What themes I'll choose, I don't know yet. The stories

142 Second Stories

sit around for a long time unwritten. I do know that I want to work in unexplored areas. I want women's sexuality, for instance, to be treated as a matter of fact. My women will be sexual all right, but I won't make a big thing about their sexuality and they won't be asking permission to be sexual either.

Cherry Jackson (b. 1941)

Productions
In the Master's House There Are Many Mansions, Black Repertory Theatre, Berkeley, 1977
Worry Beads (collaborative), Black Repertory Theatre, Berkeley, 1979

Publications
Agate Eyes (short story), Sea Urchin Press, Oakland, California, 1979
Buttermilk Bottom & Other Poems, Sea Urchin Press, Oakland, California, 1979

FRANCES JAFFER
Poet

In the remarkably short time since Frances Jaffer began making poetry, she has written *Any Time Now* (Effie's Press, 1978) and *She Talks to Herself in the Language of an Educated Woman* (Kelsey Street Press, 1979). Her poetry and personal essays have also been published in numerous magazines. Jaffer is an outspoken feminist, scholar and teacher. After a lengthy battle with cancer, she has emerged intellectually and physically energetic. As a young woman, Jaffer left the East Coast, "looking for air," as she says, went to Stanford University, took a degree in biology and worked as a lab technician before and after World War II. She is married and has three sons and one stepson.

When did you begin writing poetry?

About three or four years ago. I felt like a dam had broken and the poems started pouring out. You see, I first started to write about twenty-five years ago, in a workshop. It was recognized that I had a certain talent. I had written a poem about my son Louis who had nearly died when he was five . . . every woman who heard the poem would cry. But the men told me it needed

From conversations during March, 1978, and May, 1979.

145

filling out . . . they wanted more images about the test tubes and instruments and needles. I just knew I wasn't interested in a poem about the cold paraphernalia of the hospital. What interested me was, how do you live long enough in five years, so that if you died it would have been a life . . . Had I given my son enough love and whatever you can give a kid? And I thought, well if that's what you have to do to make a poem, with the kind of concrete visual imagery they wanted, then I'm not interested, I'm not a poet, I don't give a damn. Of course, by that time I was also falling in love with the teacher. We started going out together. So I stopped writing and got married and spent about ten years giving parties and mothering.

While you were mothering, you must have had a strong intellectual life. I read a critical piece of yours in Chrysalis *magazine. . . .*

When Mark, my husband, was head of the Poetry Center at San Francisco State University, I lived in an atmosphere of poets. I went to lectures and Mark and I really liked to talk. He encouraged my left brain . . . my sense that I was intelligent . . . something I had never experienced before . . . he kept telling me I was brilliant until I finally began to become smarter. You know, we do respond to expectations!

How did you feel about the domestic part of your life?

I cannot deny that I loved nurturing, but I didn't want to be a housewife. I really wanted to be what I thought was a courtesan . . . an intellectual companion, a sex object, a hostess.

How did you become interested in feminism?

After years of entertaining and heavy socializing, we moved to the country. I found out I had cancer, lymphoma. I made a vow that since I wasn't going to live very long, I never again wanted to do anything I didn't have to do. My son's girlfriend at the time

was a feminist. I used to say to her, you don't have to be a fanatic, and she would look at me and say, oh Frances, yes you do. And that's where I think it began. About 1970. She was one of the most important people in my life. She said, Frances, stop talking and write. I said, I can't write. She said, yes you can, I want you to. Which is when I went to my friend Kathleen Fraser, who advised me to write all my ideas in the form of a letter. That was the article you read.

From your poetry and your criticism, I see that some of the issues you're working through have to do with your illness and your mother.

During the time I was writing *Any Time Now*, I had just had a flare-up and more cancer. My therapist said, you have to go in and find your own nurturing mother because you don't seem to be able to accept any kind of nurturing from your real mother. If you go inward to your unconscious, you will find a nurturing mother there, but on the way, don't be surprised if you find your bad mother first. So *Any Time Now* is really about that experience.

Why did you write of yourself as two persona, Fran and Serafina?

Fran is the good girl, acceptable to the world of the patriarchy. Serafina is the repressed naughty girl. It's sort of an artificial division. But Serafina is the one who came out when I started to write poems a few years ago . . . the naughty girl finally speaking up.

Our culture doesn't reinforce girls for being naughty. With naughty, I think we can include adventurous, noisy, brash. . . .

Yes, which is why I have seen myself more as Fran. Phyllis Chesler said it first in *Women and Madness*, that women are

unmothered in a patriarchy, because the role of the mother is to represent the culture to her children. The mothers are the restricting ones in the family, not the fathers. Our fathers are often nicer to us than our mothers. Our mothers tell us to be polite and not stick our necks out. It's their job to perpetuate the stereotypes, though they don't think of it that way, of course.

In one of your works you talk about the need to be more adventurous. What do you mean by this?

Exploring, traveling. You understand, my middle-aged needs for comfort are very strong and just the wish to get rid of them doesn't always get rid of them. I could say that feminism by itself is an adventure out of the middle-class Jewish community of Hartford, Connecticut where I was brought up. Look, I've learned to jog five minutes without stopping . . . that seems silly to some people but at fifty-seven, that's adventurous for me!

Well, mothers haven't much history of adventure in the world. You've raised three sons. Do you see gender stereotypes in your sons that you helped create?

Yes. I know to what extent I created machismo in my sons so I have to be more sympathetic to men than mothers of daughters are. I think at this moment it's *still* difficult for even the most avid feminists to raise sons. It's easy to feel good about the effort to raise daughters without stereotyping them, because you try to give them the qualities that the culture essentially values . . . self-love, authority, strength, physical mobility. But if you try to encourage so-called female virtues in boys, you risk doing them great social damage because these virtues are in reality *not* valued by the culture. And possibly the social damages would undermine any psychological advantages that the "female" virtues are intended to provide. So raising sons to be feminists or to fit the demands of a non-stereotypical ideal is a touchy problem for a feminist parent. I've seen too many unhappy chil-

dren who are the products of the psychological experiments of my generation of parents.

What would you have done differently with your sons?

It's hard to say what I would have done then, but if I were raising sons now, I would, for instance, allow them to cry. If they felt like playing with dolls, I would probably give them some dolls to nurture.

In a review you wrote of Ellen Moer's book, Literary Women, *you said that the subject matter that most deeply interests women bores men or even offends them. Do you think that's still true?*

I think it is still true but less true. Men are not generally interested in relationships between women, and I'm not talking about sexual or lesbian relationships. I'm talking about the times between women. There are whole novels written, for instance, without a woman in them, like *Moby Dick*. Think of Jeanne Moreau's movie, "Lumiere." I was so excited about it and afterwards Mark said, "You know, I cannot understand what was so exciting to you." Now I have really educated him and he has struggled very hard with his innate patriarchal sense of what art is . . . he has struggled to hear me. If he can't get it, then we can really say it's hard to get. I mean, he has grown to teach feminist writing in his classes. I said to him, "Remember the scene by the swimming pool. There are things in that movie over and over again that I've never seen in movies before. They are what women are like when there are no men around! And you haven't seen them either and you didn't notice. Remember how giggly they were when they were getting into the pool . . . poking fun at themselves and imitating sexual behavior and wriggling around. Stuff like that," I said, "women do a lot of when we're by ourselves. It's the way we are often with each other, when there are no men around."

By the way, Jeanne Moreau doesn't consider herself a feminist, according to a profile of her in The New Yorker. *Why do you suppose some women denounce or avoid feminism or refuse to ally?*

Well, I get annoyed with them, but I'm also sympathetic. These women who are exceptional, in the sense that they have been able to be accepted by the patriarchal world, say they're not feminist when in fact their success has depended on feminism. There are many women today who have audiences and support systems and followers and readers they wouldn't have had before feminism. Lessing's *Golden Notebook*, for example, was ecstatically welcomed by feminists, which provided her with a large readership. Then, reciprocally, her writing became a spur to feminism and to more authentic female writing. And it was largely the women who got the men to take her work seriously.

But what about women who achieve recognition and don't acknowledge other women . . . the political naif or the successful queen bee. . . .

Well, with others it's sort of like the role of an "Uncle Tom." In order to get out of a ghetto, whatever kind of ghetto it is, a person often has to have a particular kind of aggressiveness, and a certain kind of ruthlessness. The particular problem women have is that we are conditioned from our earliest moments to scratch each other's eyes out for any available men. I think it's inevitable that the first women who make it are largely unconscious of how they've done it, what it's cost them and other women.

Unconsciously not admitting who helped them?

Maybe. I don't think that O'Keefe, no matter how great she was, would have become so well known without Stieglitz's help. My own poems were quite quickly experienced as interesting— because of the peculiar mixture of age and stuff that I am—but

I am aware that I had an advantage in finding people to publish them. This had to do with the women I knew because of being Mark's wife. I was already in the world of poetry.

Which women in the world of poetry do you feel have influenced you?

Susan Griffin. I think it was when I read her poems that it first occurred to me that the kind of poetry that I had originally wanted to write, one could write. And of course Adrienne Rich. And Levertov, particularly her *Relearning the Alphabet.* Of the older poets, I think my all time forever obsessive excitement is with H.D.

Why H.D.?

No matter what of hers I read, I find myself. And the *song* of her works makes me ecstatic. At first I thought her poetry was classic and boring. I couldn't get into it. Then after I'd been writing for a while I started reading *Trilogy* and have been reading her poems and prose ever since. She may be a "poet's poet," but that may be just because she's so seldom taught. Hardly anyone teaches her, and if they do they're likely to teach the early poems . . . which are perfect "imagiste" jewels. But her greatness doesn't become clear and exciting for me until the poems of World War II and after.

Hasn't H.D. been largely ignored by academics?

I want to tell you a story here that illustrates the kind of problems even the best women writers are up against in the man-dominated culture: My husband, Mark, is a poetry teacher, a feminist educated by me. Mark couldn't read H.D., even after I'd told him how I felt about her. Her poems bored and irritated him. But he took what I said seriously, so he said, okay, when you find one where the song of it gets to you, read it to me, show me what it is you like so much. I read him a small poem from

Helen in Egypt and he didn't like it. He criticized this word and that construction. Why didn't she use a simpler word, why this archaic one, etc., and I said I'd have to think about it, but one thing I was sure of was that it was not an accident. She knew exactly what she was doing, that I was sure of. So he took another look and this time paid serious and analytical attention to his own question and as soon as he did that he was able to see how skillfully the poem is constructed and the reasons for what he had thought was carelessness. He even began to enjoy a little the rhythms he had so disliked. But that's the kind of respectful attention men (and women too, until recently) don't think of giving the women poets they can't immediately understand.

Has it been difficult living with a poetry teacher? You've obviously had aesthetic disagreements.

I've educated him now just as much as he's educated me, although at first it was the other way around. Now he can read Rich, whom he couldn't read. Now he teaches H.D. to his students. He had to be receptive in the first place. I think the thing you have to realize in writers, artists, men teachers is that they can be feminists politically, but their identity is totally locked up in definitions of art that they themselves had to learn at some cost to other sides of themselves. It's the same thing with Uncle Tom women and men who've had to cut out some part of themselves. They are very reluctant to admit that they had to do it, and to allow those parts back into their sensibility and judgment.

You refer to your husband a great deal when speaking about aesthetics. Are you measuring your literary values against his?

Well, he tries very hard to understand the possibility that there might be a separate female aesthetic, and when he fails to understand a work of art by a woman, such as Judy Chicago or

Adrienne Rich, when he simply can't see or can't hear, it makes me feel: If *he* doesn't understand, look what we're up against!

In a sense, isn't that still looking to the patriarchy, as you put it, for validation?

Absolutely. What I'm saying by indicating the need to develop our own feminist aesthetic and then bringing Mark in is that sometimes it's a waste to worry about that male judgment, because even the best of them don't understand much of our work. I am voicing a reminder to myself, living with an articulate and feminist teacher and poet, that there is a constant temptation and seduction to look to men for approval. This is particular to the heterosexual woman, wanting the approval of daddy.

There is a siphoning off, a co-option of female values by the greater male culture, not just in art, but in all fields. Where is the power? The power of immortality in art does not lie with females! Has not. Elizabeth Barrett (Browning) was the most popular writer of her time, but now popularity is a dirty word. Who controls the anthologies and journals of prestige in this country? Not women! If anything, the art of women is localized, not nationalized, in terms of an audience.

How do you think the art of women can make a greater impact on the culture?

Women must be willing to be followers of women. Our primary task is to pay attention to what women are doing. I use Mark as an example of why we have to do this. Our most interesting, experimental works in terms of language are not going to be recognized or appreciated by even the most educated, feminist men. I think I'm more aware of this than other women, because I have to live with it.

Would you say that women need a lineage of women artists to whom they may look, as men have always had?

I think it imperative that we do. If we had feminist criticism of Gertrude Stein, we might find what in her work is useful to us. The reason I push for a female aesthetic is that there is a realm of experience that women may write about that is not recognizable to men. Some of our most original work is stunted because it's never looked at by men. If we don't explore what it is that may be specifically female in both acclaimed and unacclaimed writers, then that information won't be passed on to the next generation. We need a tradition to stand on and to proceed from. Avant-garde male artists fight a male tradition in art. It's not adequate for women to jump in and help them destroy what came before them. How can a woman write de-constructivist poems when the men are attempting to de-construct a language that has *never* really been women's? In attacking the language, we attack their language, not ours.

What is your experience of sexism in the art world?

Many men do not see aesthetics as an appropriate place for feminism. I think all of us are quite willing to give up what we don't care about too much. You find, I think, in the art world, that it's easy for men to be political feminists and make a lot of noise about letting women in. Notice the word, "letting."

From your perspective, what might account for a female aesthetic, if such a distinction exists?

Well, I can speak best about poetry and I think it has a great deal to do with the left brain and the right brain. Even if it's only a metaphor, it applies. If I understand it correctly, the right brain has, in most cases, very little or no language, and yet it wants to communicate. We can superimpose notions of the unconscious on the right brain because it doesn't speak. Much of the inspiration for poetry . . . the source of it . . . the field from which it comes is the right brain. The language used in poetry comes from the left brain, where language originates. But the language

of poetry is a combination of impulses from both brains. And still it's a different kind of language—not rational, spatial. Its concept of time is circular.

I think if we are really in touch with that source of inspiration, we may find out much more about who we are. We will have access to a more authentic picture of ourselves. In children, if there is an accident and the left brain is damaged, the child can learn language, but in adults if there is an accident, the amount of language the right brain can learn is very limited. This dominance of the right and left brain is apparently subject to early conditioning.

Yet, from an evolutionary perspective, maybe brain dominance is as necessary as, say, division of labor.

Well, the development of civilization has until now required dominance of the left brain, but this has been much more reinforced in boys than in girls. If women are more intuitive, perhaps that has to do with greater connection with the right brain.

The left brain, which can focus, is called field independent. The right brain, which is diffuse, is called, as you might expect, field dependent. If you are interested in ecology or feminism, you could, as a friend of mine has done, say that right brain is field relevant and left brain is field irrelevant. The problem of field irrelevance is the greatest problem we have in the world; it allows us to have overpopulation, atom bombs, et cetera, because we just abstract one item alone and focus on that, with no interconnections. This is the opposite of ecology. I think that's why it's important, not just for ourselves, for women to write out of our own experience, in order to add to the culture. Our experience may be more field relevant! Up until now, the majority of women the culture has accepted into print have been those with more left brain orientation.

In other words, those women whose writing reflects male thinking?

It reminds me of when I was a girl and I went to an Episcopalian boarding school. They said, It's fine if you want your Jewish daughter to come to our school, but she has to go to church on Sunday. So I went, and I went to church and learned to think like a Christian. That's the way women have been let into the wider culture, which has been patriarchal. You have to learn to think like a man. Like the line from Yeats, "did she put on his knowledge with his power?" Do we in fact put on their knowledge with their power when we marry men, when we live with them, when we enter the world of male power? We take on their way of thinking. In order to further understand this issue of a female aesthetic, some study of the language of conventional criticism is useful. For example, these are words of praise: strong, sinewy, lean, tough, spare, firm. Now think about a man's body. And then think of these words: damp, padded, soft, gushing. Now think about a woman's body.

I see what you're getting at, that physiology may dictate certain aesthetic judgments?

You begin to realize that nobody writes from the neck up. And we have been forced to have as aesthetic criteria the definitions of the male body. The definitions of our own bodies, from which we write, are the very words which are unacceptable as aesthetic criteria in the patriarchy.

So you would say that men write from their bodies and write of their sexuality?

Yes, they write from their own landscape. Ellen Moers talks about the landscape that certain writers write about. Moers defines brilliantly how a girl child experiences her own body— not as a boy child, not as a man experiences a woman's body— but how, when you masturbate, you experience your own vulva and what it feels like to you. Much of the male landscape, much of male literature is based on masturbatory experiences of their

own bodies when they were children, their deepest unconscious attitudes towards their bodies. Phallic doesn't mean a penis anymore, it is a whole aesthetic concept and there is no aesthetic equivalent for the female body in the language.

Do you suppose that might be why we're having so much trouble figuring out this business of aesthetic criteria?

Yes, and I think that's why we have to be uncritical in many ways. Because not only are the standards culturally male, but physically male as well, and we really don't know where to go for our standards.

But if we are uncritical, how are we to assess literature written by women?

Look, when a woman first writes about menstruation, the whole world is excited or shocked. What a thing to write about! Anybody who wrote about menstruation was an artist for a while, you know? But now there are certain female subjects which have become cliché and boring. I think it's very important to say, okay, we've heard plenty about that, what have you got to say that's new? You really ought to read more of what women are writing in order to see what's cliché and go on to write something deeper, less "easy," more your own. We tell young art students to go to museums so that they don't paint Cezannes all over again!

Aren't we looking for new information from women and the fresh handling of it?

Yes, but our standards should not lie in the inherited standards that have been given to us by men as to what is and what isn't acceptable. The criteria have to grow from what has been written by women . . . though unfortunately we can't exactly start from scratch as if there were no other literature!

Frances Jaffer 157

What about the whole business of subject and object in art and the artist distancing herself?

It is possible that even the term "aesthetic distance" is male, if you remember that men and women both have mothers. For a long time, babies probably don't know the difference between themselves and their mothers. So the relationship between the female self and the "other" is not going to be the same as it is for men. That is to say, a man learns to distinguish between himself and his mother fully . . . there is a real relationship between him and the "other."

But most women never quite make the break?

A mature woman relates to the environment with a kind of identification that men don't experience. A man doesn't think of his mother as himself, he separates himself more violently from his mother. I imagine, therefore, that feelings of objectivity and subjectivity might be different in men and in women. So I think that feelings of subject-object relationships in art are likely to be different in the female aesthetic.

That contradicts the entire academic, formalist notion of aesthetics . . .

You see, what we are saying is really very radical and very dangerous because we are redefining art. We might redefine art to include this different relationship between subject and object.

The way you're speaking of subject/object relationships reminds me of notions in modern physics, particularly the attempt to measure sub-atomic particles. The particles can't be separated from the measuring devices and still be measured accurately . . .

Yes, I think we will hear more about this from the sciences—

from the chemistry of newborns, from anthropology. We'll find threads everywhere. But I think the first job of women artists is to be as authentic as we can to find out as accurately as we can what each individual one of us experiences . . . in order to avoid stereotypes and in order to find out as much truth as we are able to.

You said in one of your articles that we've been so conditioned to be who we are that we don't even know what we feel.

Yes. When you look at a picture of maternity, the madonna and child, you think, isn't that touching, isn't that sweet. This is all you see. But maternity is not like that. There are so many unexplored areas. Most of the images of women we have are from the eye of a man. And women very seldom write about male bodies or paint them. Women's love poems are usually very narcissistic and have to do with how it feels to be loved . . . Erica Jong (and so much of her stuff has been scorned) writes a lot about men's bodies as men write about women's bodies. I really wish more women would write about how men's bodies look to them.

I mean, men *are* sex objects to heterosexual women. The thing that women detest about being sex objects is that we are seen *only* as sex objects. I think that to be a sex object is okay, but not only a sex object!

Earlier you talked about female landscape. What about questions of male and female space?

Whatever power women have generally exercised has been confined to a particular space—the home; not only child rearing and domestics but the grubby and dangerous stuff of social existence, like giving birth and mourning death and disposing of feces. Perhaps this enclosed female space creates compression. The compression in any enclosed space is potentially explosive. I think that when the enclosed space explodes, it does so in extremes, such as what they call melodrama. Melodrama, which

is looked down on as an art form because of its extremes, may in fact, at this time in history, be a legitimate and authentic female art form. In the larger culture, perhaps, this kind of explosiveness isn't necessary, so it feels fake. For women, it may be true, that is to say, authentic.

You're positing that art may be different for men and women?

Well, between subject/object, female body, and melodrama, we might imagine that the female aesthetic, if it were authentic, might be different from the male. These are only three ideas. It's the job of feminist artists and critics to investigate these things freely, without recourse to what the men are going to say. We don't, after all, want to be *allowed* into the existing culture, we want to enter from a position of strength.

According to what you've said, feminism is injecting something big into aesthetics that wasn't there before. The ideas behind a female aesthetic actually contribute, rather than separate. Are you really talking about pluralism? Is this the time in history for various aesthetics to be operating?

Yes, I think so. Not to mention Third World artists, Blacks, Hispanics, Asians. Even, perhaps, for an individual artist, one does not necessarily have to discover the "single strand" as men have required. A poet named Alice Mattison, in a poem called "Ordering the Priorities," says, "focused like the crotch of a boy," and "the day has no metropolis/no back country either." Certainly as feminists we have to be as pluralistic as we demand the world to be, aesthetically as well as politically. And paradoxically, that requires a tremendous unity in the women's movement, an agreement to be pluralistic. But without that, what can we hope for?

I'm not sure, then, that we can even consider this in light of what you said about subject/object, but what about the formal qualities of literature written by women?

I think it's an important issue to address ourselves to, since we are exploring female forms. There have been a lot of questions, for example, about rhythm. Some poetry written by women might be longer on the page. I am going to give a very extreme example . . . a man makes love and it's over, a woman makes love and it lasts nine months . . . okay, that's exaggerated. The issue of women using too many words. Too many for whom? Our softness, our padding, our roundness . .. this is our female shape! I am often told, pare it down, pare it down to where there is not one extra word. But who is defining the extra? What is defined as extra may just be different!

Do you suppose the male ear has been trained differently?

Perhaps. If you consider that the right brain experiences circular time and the left brain experiences linear time . . . well, that might make a lot of difference in terms of poetry and art in general. I think it is an area where we can be curious, rather than critical. We have to understand questions of taste. Is this bad taste or in fact legitimate female taste, and what, in fact, is the difference? The colors that Judy Chicago uses are offensive to men, I think, but pleasing to women. I deliberately made the cover of my book pink, as a feminist gesture. We must reconsider questions of vulgarity. In any case, my feeling is that we should not define ahead of time what we think female form is, but when we find something we like and that men don't like, we can be curious about it. What I'm recommending is curiosity: permission to ask ourselves questions that arise from the discrepancy between what we feel we should like and what we do like.

You've spoken a great deal about the general difficulties for women making art. What are your personal stumbling blocks?

Other people's opinions.

How can you counter them, what do you need to continue your art?

Frances Jaffer 161

A greater ego, contrary to what people usually think of me. A greater sense of following my own direction, instead of doing what I think I ought to do because other people say so. I am extremely vulnerable. That's why I stopped writing twenty years ago, when the class told me that I had to write differently. Instead of writing the way I wanted to, I just stopped writing.

Do you think women often internalize criticism and crumble psychologically, instead of defying it and pushing on ahead?

Yes, and I think it's part of conditioning. It's certainly part of my conditioning, this lack of autonomy. I often experience it as a form of stupidity in myself.

But you're in a different position now, you've experienced some measure of success.

Well, when I started writing in 1974, I was in a very good position. I knew I was no good. I thought I had talent, I knew I was trying to write out of a feminist impulse, so that any standards were irrelevant to my work. And I think I succeeded. I wrote some original poems of female experience. I could simply say pooh-pooh to what other people said, because I felt that nobody was doing what I was doing. That gave me the freedom to write. And I wrote a lot.

How has this original freedom changed?

Inevitably and gradually, the more I wrote the better I got in terms of craft. I went to workshops, I listened to what people I trusted said. I think I developed a great deal over five years. Now I think I read more intelligently. I'm surrounded by people with great skill and intensity of ideals. I've been accepted and published in national magazines. But it has become very hard for me to just go ahead and write out of my own impulses. And

I've internalized more criticism since I began writing, as a form of self-editing.

Perhaps that's an indication of a maturing artist?

Inevitably when you become deeply involved in language, you get a different sense of it. You get bored with what your experiences were. You reach for something new. And I believe that poetry, in particular, deals with language and the unconscious. And that's where it has to come from. I must go deeper into my unconscious to find the future language.

Frances Jaffer (b. 1921)

Books
Any Time Now, Effie's Press, Oakland, California, 1978
She Talks to Herself in the Language of an Educated Woman,
 Kelsey Street Press, Berkeley, California, 1979

Magazines
*Aphra, Best Friends, Big Moon, Chrysalis, Feminist Studies,
 Foothill Quarterly, Ironwood, Shocks*

Other Collections
Omens from the Flight of Birds (journal entries), Stephen
 Vincent, ed., Momo's Press, San Francisco, 1978

ELEANOR LAWRENCE
Photographer

Eleanor Lawrence was born in San Francisco in 1910 and has lived most of her life in Berkeley. She attended Berkeley High School and the University of California. Forced by the Depression to drop out of college, she returned some thirty years later to take a B.A. in Art. Long active in politics and surrounded by a political family (her father was the first Socialist candidate for mayor of San Francisco), Lawrence did documentary photography for the WPA. She spent many years working in commercial darkrooms and selling photographic equipment, until she suffered a stroke at age fifty-nine. It was at that turning point that Lawrence decided to devote herself to her long-neglected art. She has had numerous exhibitions of her work and her photographs have been published in such national magazines as *Natural History*. Several of her photographs also appear on album covers of her late sister, Malvina Reynolds. Lawrence works primarily in close-ups. Her pictures distill the fine details of fruits, flowers, and leaves. She describes her work as urban nature photography. She is married and has one daughter.

From conversations during December, 1977, and January, 1978.

You've lived in Berkeley most of your life. What was it like when you were younger?

It was small and wonderful, with certain of the qualities it has now. That is, you could be more Bohemian than most anywhere else. California girls even had a reputation . . . we were known to be freer. And, of course, the surrounding area was countryside. The girls would go walking in the hills at night and never give it a second thought. I liked it then because I always felt free to wander anywhere I wanted.

You must have seen Berkeley go through generations of change, particularly the area around the university.

Telegraph Avenue is a special place. It was a strange place during the very worst of the dope era, but then it was always oddball. Back in the '30s, the fraternity boys were making their own beer during Prohibition. Crews of fellows were riding in open cars around Telegraph and Bancroft, when the street ran right through the campus. They would shoot each other with seltzer water bottles. Everybody hung around the Black Sheep coffeehouse and discussed world problems. It's different in degree now, but not in kind.

How has the area most changed?

Suddenly during World War II, there was an influx of people, the military influence, people who had different values. It was just population explosion, I guess. When I was thirty-five, there were 18,000 people in Berkeley. You know, I went to junior high school here, and to Berkeley High for a while. Then I went to Cal directly after high school. I was in the class of '34.

How did you come to live with your sister, Malvina Reynolds?

Well, my father's business had gone bankrupt and we had to move to Los Angeles when I was eight. I was growing up in San Pedro. I was on the street a lot. My mother was working in the shop all day, and my parents got worried that I didn't have adequate supervision. So they sent me up to Berkeley. Malvina was already in graduate school . . . we were ten years apart. She sort of assumed the role of a mother, but when I got to be seventeen or eighteen, I became rather in the way. We would get interested in the same guy and that was real trouble! Conflicts developed about the way things should be. She was a writer and more verbal, and I was much more physical and mechanical. Then she began to feel that she didn't want to restrict me but it was her duty. Finally, we separated. We had many differences all our lives. Our husbands at one time hated each other. Anyway, our lives diverged. We didn't see much of one another later in life, but we got along.

Were you doing any photography in those days?

Well, I'd gotten interested in photography very early. My brother played around with developing negatives and it looked like magic to me . . . I took it up as a "hobby." There were periods when I dropped out of school for economic reasons. Many of my friends did too. They went to work in canneries, I went to work re-touching for a photographer, which I hated. But I always tried to get work in photography somehow.

Were you doing your own work at the time?

I was always doing a little of my own work, but I stopped when I became so politically active that I didn't have the time. I was a member of the Communist Party until 1947.

How did you become involved in politics?

Eleanor Lawrence 167

My father was a socialist and pacifist during World War I and later he was the first socialist candidate for mayor of San Francisco. The socialist party was organized in my father's tailor shop. He was brought in at the time Tom Mooney was put in jail. If my father hadn't had a shop full of women who alibied him, he'd also have been in jail. My first husband was also active in the Party, so I was surrounded by politics all my life.

Did your politics and art interfere with one another?

They sure did. The Party would tell us what was acceptable. I was specifically told whom and how to photograph. When I didn't agree with the politics, I was told my art was wrong.

I assume that your art won out?

It did. But only after such a struggle that I got sick, I didn't mind taking pictures of other activists, events, demonstrations. But I encountered a situation where I knew perfectly well that if I went in with my camera, it could get smashed. Getting smashed myself was bad enough. But I didn't have any insurance for that, I didn't work for a newspaper that would take care of me. And I didn't have that kind of drive, I wasn't interested in chasing ambulances, I didn't really want to be a photojournalist. But that was the only kind of photography the Party would consider as real.

What kinds of situations did you photograph?

Well, once I was asked to photograph a spy. And I did it but I was very nervous about it. It wasn't the way I wanted to use my instrument at all. It was a dirty job, a little like taking mug shots. This was during the Spanish War. One of the fellows I was working with wanted me to lend my camera to someone else. I said no, I won't do it. He said, I'd give my life to the Party. I said, okay, give it, I won't give my camera. And that was that. And he went to Spain and died.

Do you think there's anything worth dying for?

No. And I was raised to think differently. You don't die for a cause, you live for it. This is something I argue about with people a lot. It's come about from long experience. I can remember when I was in my early twenties and we would go to a demonstration and we knew that there was going to be violence, that people were going to get their heads smashed. I was the secretary, I had information on my person. I was once arrested and the rule of thumb was to make it as difficult for the authorities as possible. You don't have to throw yourself under any wheels, you just resist. If you have to tell them something, you make it up.

When did you first try to get work in photography outside of the movement?

In 1936, when I went to New York to be with the man who was then my husband, I tried to find a job. There weren't any. I went from one photographic establishment to another and finally got to Wagner and Wagner, whose work I had seen published in photographic magazines, and met the young woman at the desk and she said, we don't hire women. Period.

What was your immediate reaction?

What could I do? She was the sort of person I knew there was no point in saying anything to, so I just turned around and walked away, out into the snow. And I tried the want ads. I was only going to take a job in photography. My husband's relatives kept telling me to take a job at anything. They said, do housework, so he can stay in school. Well, I had done housework and I wasn't doing it any more. And so we left New York and came back to California. I did a little documentary work for the WPA in San Francisco, photographing young itinerants coming in on freight trains. My husband was an art historian, and he was in a WPA project that took him to Death Valley where he'd find natural

pigments and grind them for painters to work with. I went along with him and took a few photographs. Mostly I worked in camera shops or photo laboratories.

Did you ever do anything with your photographs, sell any of them, have a show?

I did very little of that in those days. You have to remember, photographs weren't necessities at a time when necessities were all that mattered to people. Who had money to buy photographs? The Party wasn't receptive to an artistic use of photography. Buying photography as an art is really only something that's developed in the last ten or fifteen years. My first published picture was in a waterfront paper. Once I showed my pictures at the California Labor School. I would do my work on and off . . . six months would go by and I wouldn't do anything.

Why did you suddenly start working for yourself when you were close to sixty?

I was tired of selling cameras. I had been thinking about going back to school and finally finishing up. I'd been thinking about it for thirty-five years. You see, I quit Cal in 1931. I kept wishing I knew more about this craft or this art, I'd think some more about school, but I never could bring myself to go back. Working in camera stores got me through raising my daughter, but she was grown and in college herself. So I went back to Cal in 1968. I entered with junior standing when my daughter was a junior.

How did you feel about being in school after all those years?

More relaxed. I didn't make straight A's or Phi Beta Kappa the way my sister did or the way my daughter did. But I realized that I didn't have to in order to be worthy of getting an education. The background I come from pressured you to either make

straight A's or not go to school at all. Malvina used to say, well, then the ones who need it never get to go!

What made you decide to major in photography after all the technical experience you had?

When I started to choose classes, I wanted to take everything but photography. I took printed textiles, visual communication, all sorts of great courses. But when I finally had to choose a major to graduate, my advisor said, well, what are you interested in? I said, I guess, photography. So you see, going back to school actually congealed what I had been questioning all those years.

When do you think you got serious about photography as your art?

A few months after I graduated, I had a stroke. So that retired me. I was pretty sick for a while, paralyzed from the shoulders down on one side. But I recovered completely, with very little residue. After that, I couldn't work at a job where I'd have to stand all day. When I had to quit working for money, I was freed to do my own work.

Besides working in camera stores, what other kinds of jobs did you have in photography?

At one point, I worked in a commercial darkroom and printed eight-by-ten contact prints all day long. I learned a lot about developing and printing. There were a lot of women in those shops. Then men were the photographers and the women were working in the laboratory and the finishing rooms.

Did you have anything to do with unionizing commercial darkrooms?

When the unions came in, they were only after big plants, with fifty or so employees. If there was one woman working in a little shop or studio, they just didn't bother to unionize. But one time I was working in a big shop. The union organizer came and met with resistance. The shop employed a lot of army wives who worked for very low wages. One of the army wives said, Well, maybe we're only going to be here a little while; why should we join the union? And so the union organizer said, Well, we know you army wives. He never explained anything to us. So I said, Well tell us what benefits we would get by being in the union. And he said, What do you mean, death benefits? The organizer was pretty stupid. I went ahead and paid my dues, but the guy didn't know anything about photography or the people who worked in the trade. He came in with one of these catch-all trade unions. He'd always worked with men in paper mills. He didn't know anything about organizing women and he didn't want to know about women.

Were there any women in the first unions?

Well, yes, they had to be in unions if they worked in the ship-yards. There were a lot of women there; Rosie the Riveter, she was a hero. But photography workers weren't that important.

Were there many women photographers in those days?

The best women photographers were in the Navy. Really. Or in the Army. They could have their security there.

Do you think that photography was easier for women to break into than, say, painting?

I used to sort of brag about the prejudice I encountered as a woman in photography and politics. But photography came along a little over a hundred years ago and women's suffrage came along right after. So women were in photography right away. There was Julia Cameron, and there were many others.

But the majority were and are still men. Outstanding women, like Margaret Bourke-White, still had to be twice as good as men to get recognition.

Were there photographers you studied under, either before you began to take your work seriously or after?

Not really. I learned on the job. I would have liked to have a mentor. A good mentor sets you free. It could have been possible when I was in my late twenties or early thirties. I went to Imogen Cunningham and she said, Go study with Weston. But at the time I was married, and I knew if I went to study with Weston I'd have to go to Carmel, and I knew I couldn't do it. It probably distorted my career, not to go.

How did you meet Imogen Cunningham?

Oh, it was so long ago that I had hardly even bought a camera. I had a boyfriend who knew I liked photography. He told me about a meeting that was going to be held on Shattuck in Berkeley. It was the original f/64 group. I was nineteen or so. They were talking about photography and painting. I piped up from the back of the room: Well, photography is just a different medium than painting. I heard later that a professor of aesthetics told someone that the only sensible thing said at that meeting had been said by some little girl in the back of the room . . .that was me. That was the group that started out with Imogen and Weston; Brett Weston, his son, was there too. Imogen actually came over to me and spoke to me and invited me to come and see her.

What sort of relationship did you have with her?

Well, I would go and see her once every few years. She was like my godmother, like a mother without the involvement or anxiety or angers that are directed toward a mother. I would bring her my work and she would sometimes call me lazy; I wasn't work-

ing hard enough to suit her. Her criticism was good, but it was quite sharp. On the other hand, she was always constructive with me, she hated people who criticized cruelly. As she put it, you don't destroy people with criticism.

How did you feel about her?

I admired her enormously. I never felt warmth from her. Imogen was a person who made her way by sheer force of character in a time when it was much tougher for women. She was a no-nonsense person. I could accept that kind of singleness of purpose from her. I couldn't accept it from my own mother, who also had the same kind of deliberateness. They were both red-haired, willful, and fiery. But Imogen was forthright and completely honest.

Did she have many young photographers in her circle when you first met her?

Yes, there was always someone under her wing. I actually met my second husband on a visit to her house. I met him on the street, he was coming to visit her also. Imogen was always much easier on men. She liked to photograph men better than women, because she said they didn't have the kind of vanity that women are given to. And because, I think, she had three sons. If she'd had daughters, she might have felt differently.

Do you think she was harsher to you in her criticism because you were a woman?

No, she was harsher to me because I was more Left! She really didn't approve of anybody who was as Left as I was politically. After all, I was in the movement to the point of learning how to use a rifle. This was in earlier times, of course, when I first met Imogen. Anybody who has handled the weight of a 3¼-by-4¼ Graphflex camera can do pretty nearly anything.

It's hard to think of a camera and a rifle at the same time.

They're not that dissimilar. When I was selling cameras, and had to teach people how to hold them, if they'd used a rifle, I could make the analogy and it was easy. You don't jerk, you squeeze, if you want to hold on target. And the kick comes after. In fact, with a sixteen-millimeter Bolex movie camera, they make the holster to look exactly like a rifle holster. Of course, now I have nothing to do with guns.

When did you change your mind?

When they dropped the bomb. To me, radicals who are still using rifles and handguns are adventuristic and stupid. I've come to a much more eclectic position about politics than I had when I was a Party member. You see, when you're a Party member, you have to adhere to a particular principle. You mustn't get diverted by other lines of thinking. Having lived for some years now, I find that there are other people who have a hell of a lot to offer. Even churches. All ideas have a right to stand or fall in the market place. Guns and bombs aren't the way.

It sounds as if you got more tolerant as you got older, nothing like that cliché of getting more conservative in time. . . .

Look, I see my friends getting conservative and I can't tell you how much it pains me. When friends of mine would say during the sixties, these kids have to shave off their beards, I thought where the hell has the movement gone! I could always see what was going on with young people.

And with women? Have you always identified yourself as feminist?

I hadn't thought of myself as a feminist, but when I was younger, the fellows in the Party knew I wasn't taking any guff from

anyone. The women's movement in the sixties made me realize I had probably been feminist early on. You see, I had always thought of myself as rather more a left progressive, but I went through a time when people said, Well, you got the vote, what more do you want? Well, I'd say, blacks got the vote and they're still hollering. As long as there are differentials in treatment, even in radical movements, there'll be a need for more hollering.

What about Marxists who continue to feel that the women's movement is a sub-category, or that world-wide socialism will take care of everything?

That's exactly what I meant. Always take care of everything else before women! Baloney! Once I saw a picture of Gus Hall in an election campaign and somebody else who was running for vice president. There was a great big picture of Angela Davis but she wasn't running for anything. Goddamn them, she was good enough to speak but not good enough to run for office? I get very angry because the Party doesn't have women in top leadership. You ask that of unions, you ask that of business, why not the Communist Party? They're losing women. Many people of my generation have dropped out because they've been alienated, because the Party has no sense.

In the sixties, many women's liberation organizations were splinter groups of the New Left. The first organizers came right out of SDS.

The same thing happened over and over with Leftist political movements. It happened to my daughter. Young men in SDS were coming from the child-rearing of the '50s, with Philip Wiley's "momism" in their ears. Suddenly women, mothers in particular, were held even more responsible for mass neurosis. The men were busy with their jobs, the women were raising kids and whatever they did was wrong. It's part of the reason women had to split off from Leftist movements . . . they had to find themselves.

I take it you are more impressed with the women's movement of the last ten years or so than with other political movements?

I sometimes think so. After all my years of involvement with politics, I was really moved by the international women's conference. It gives me goosebumps . . . the acceptance of lesbians, the platform of the third world women. No one came with a cut-and-dried thing everybody had to accept. This is a revolutionary change in politics. The old kind of politics would say we failed if our slate didn't go through. But if you come in and make a new slate right there on the floor, then it has real meaning. What I saw in the old Leftist movement was just another rubberstamp by comparison.

I'd like to talk about your work. Do you have trouble concentrating?

I don't know anybody who doesn't. On a day like today, to go into the darkroom takes the willpower of a saint.

How do you overcome that?

Most of the time just by doing it. Once I'm in the darkroom, that resistance disappears. Who wants to go into that black place? I'd much rather be out shooting on a sunny day. But printing is very important to me. I probably get as much fun out of printing as I do shooting. I can stand about two or three hours in the darkroom at a time. I have worked eight hours a day in the darkroom, but I come out feeling like a mole. It gets to be pretty sickly. When Imogen talked to me towards the end, she said, Photography isn't a very healthy occupation. You go into the dark and come out in the dark. Of course, if you have somebody doing your darkroom work and you stay outdoors shooting, you can get pretty healthy.

Have you always developed your own work?

Whenever I've moved into a new house in Berkeley, I've put in a darkroom. On the back porch, in the laundry, somewhere. Once I was developing pictures on an ironing board in the bathroom.

Have you always done your own work in your home? If you could, would you choose to work in a studio outside your home?

I have enough money to rent a studio and I choose to work at home. I like the idea of working at home. My work doesn't demand a lot of space. I really like the ability to go from my kitchen to the darkroom and back and forth.

But many women artists have been forced to work at home for financial or domestic reasons.

I knew a woman who went into a closet to write, because that was the only place she could disappear from her little boy. But I prefer to work in my home. Why spend time going from one place to another? I like it that my work and life are integrated. I get a lot of creative satisfaction out of cooking. Now sometimes I make lousy food and sometimes I make lousy prints, but I get that same feeling. Furthermore, when I'm cooking vegetables, I can enjoy color, something I don't get from photography. I've also photographed vegetables. I've taken pictures of my husband kneading bread. I had to make the dough! Photography and cooking do come together for me, so I like to have them near one another.

Do you feel obsessed by your work?

I wish I did. I'd produce more.

Then why do you make photographs?

Because I feel that there are certain beautiful things in the world that have to be recorded before they go away. Because everything is ephemeral to me, and nothing is the same from one minute to the next, whether it's because of the light or weathering or time. The things that are important for me to look at long enough, I want to keep them.

Who would you have chosen to study with, if you had the chance?

At one time, I would have chosen Weston. If I had felt free to do it. But later on, and especially after I resumed my work, I don't think so. He wasn't flexible. I felt there had to be more ways of looking. I started working in photography thinking that Weston was the only way. But he had to be the way he was. Any person who's going to be great has to be convinced that what he's doing is the only way to do it. A single-minded vision.

Do you feel single-minded?

I feel probably that my work is weaker to the extent that I ought to be single-minded.

Do you think you'll develop that single mind?

I don't know. I have to see how my work grows. And I expect to grow.

It's been less than a decade since you've totally concentrated on your work, so in effect you're just beginning. A rather experienced beginner.

I've had other people say, you speak as if you were just starting. Well, it's true, in a way.

Who influenced you the most?

Probably Imogen. I would go to her specifically to be influenced. But she was so rich that I couldn't take much of her at a time. I couldn't assimilate her advice because I wasn't working steadily. For the longest time, I felt I couldn't go to her unless I had new prints to show her, and not just any old thing, prints she'd feel were worth looking at. And she'd catch up on me in five minutes, everything that'd happened to me in three or four years.

What kind of problems do you have in your work?

Oh, the problems are enormous. One is actually choosing the area in which I want to proceed. It took me a few years to come up with the idea of urban nature. The other problem is sticking to things, not getting distracted. There are other problems with technique, during those periods when I'm not producing very much. What happens is that I get out of practice. I had put it away for a while and there were huge technological developments I had to familiarize myself with. If you take off from photography to raise a baby for four or five years, there's an enormous gap left between you and the latest techniques.

Do you plan for the future?

Oh, sure. Oh, I know I'll die, I just don't believe it. You don't begin to believe it until you're over fifty. I mean, can you imagine a world with yourself gone? Of course not! On the other hand, when I was deathly sick, I said to myself, well, either I'll make it or I won't. I just assumed I would make it. I had been in the hospital for a couple of weeks, paralyzed from the shoulder down. A young doctor came in and told me, well you're going to stay that way. The nurse got furious. She spent an hour telling me that the doctor shouldn't have assumed what he did. That nurse's anger was what helped me. Something happened, because I went to sleep that night, and the next day, two fingers moved. In a situation like mine, I was supposed to move my foot first. The only other time I cried during that whole illness was when I reached the point that I could bring my two hands

together. Then I knew I could hold the camera. That was when I was sure I was a photographer.

Eleanor Lawrence (b. 1910)

Exhibitions
1939 Mills College, Oakland, California
1945 California Labor School, San Francisco
1952-1965 Camera Shops, Inc. Gallery, Berkeley
1958-1979 San Francisco Art Festival
1965-1967 Arts and Crafts Co-Op, Berkeley
1968 The Quest, Berkeley
1970 Friends of Photography, Carmel
1971 Image Circle, Newman Hall, Berkeley
1971 University of California, Department of Architecture
 Library
1971 The Gallery, Berkeley
1974, 1975, 1978 Egg Shop & Apple Press, Berkeley
1975 Federal Savings Bank, Berkeley
1976, 1978 Bacchanal Bar, Albany, California
1976 Concourse, Bank of America, San Francisco
1977 College of Marin, Kentfield, California
1978 Camera Shops, Inc. Gallery, Berkeley

Awards
1967 San Francisco Art Festival, Art Commission
 Purchase Award

Publications
Natural History, 1968
"Something to Sing About," Okun, Macmillan, 1968
RSVP Brochure, Berkeley, 1971
San Francisco Art Festival Program Cover, 1971
Women's Song Book, Women's History Research Center,
 Berkeley, 1971
"The Albatross," by Malvina Reynolds, Tungsten Records,
 1969 (record jacket)
Malvina, by Malvina Reynolds, Cassandra Records, 1973
 (album cover photo)

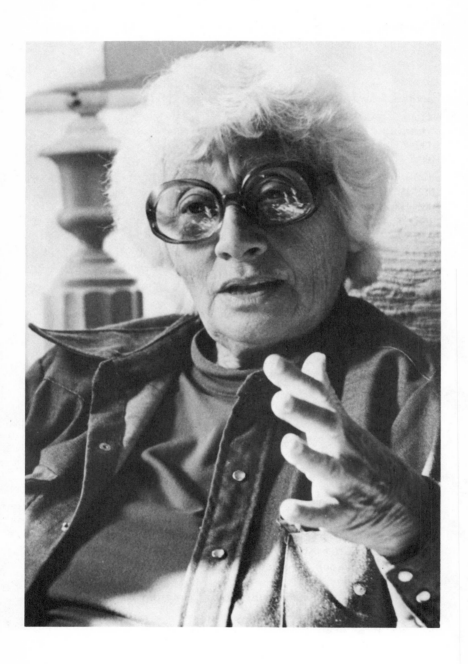

MALVINA REYNOLDS
Singer, Songwriter

Pete Seeger called her "some sort of miracle," but she once wrote in her journal that "if there's something to be said about me, I'd rather say it myself, singing." Malvina Reynolds composed hundreds of songs in her twenty-five-year career in music. Born in San Francisco in 1900, she worked in a steel foundry, then in social work, later as a newspaper editor, and also earned a Ph.D. in English language and literature from the University of California in 1939. She recorded seven albums and many singles. Her songs were also recorded by Pete Seeger, Judy Collins, Joan Baez, Harry Belafonte, Diana Ross and many others. She authored numerous songbooks, several for children, and was the subject of the documentary film, "Love It Like a Fool." Malvina ran her own publishing and recording company while she toured regularly around the world, singing her tunes of protest and delighting her audiences with her wry but gentle sense of humor. She lived in Berkeley for forty years, was married, and had one daughter. Socialist, feminist, environmentalist, activist, performer Malvina Reynolds died on March 17, 1978, two months after this interview was conducted.

From a conversation during January, 1978.

What happened to you that at age fifty you decided to start performing?

I was a writer. Before that, I used to tell stories to the kids in the neighborhood when I was little. They would gather around the steps of my house in San Francisco where I was born. Later I always thought of myself as a writer, but I was timid and self-deprecating.

How do you mean "self-deprecating"? Personally or within your work?

Both. I knew I had potential but I didn't have enough confidence in the stuff I wrote, or in my ability to break through to the business world of magazines and publishers.

What were you writing?

Stories, poems. I didn't write songs then.

That was when there were no small presses. You had to break through New York or not at all . . .

Right. I would try and then I'd get a rejection slip and I was through. This was when I was in my twenties. Then I got my doctorate. I thought I could teach and be able to write also. But I never could get a professional job because I was on the subliminal blacklist. It was partly my parents being socialists and anti-war. In the late '30s, I fell in with the folk song movement. There were hootenannies around Los Angeles where I was living at the time.

That was the Woody Guthrie period?

Yes, and Pete Seeger. It was in the air and I found that it was absolutely right for me. The songs were very realistic and yet understated and deceptively simple. I was immediately at home

in this material. It gave me the vehicle I was looking for.

Was it the politics that drew you?

Politics were involved too. Many of the people who were interested in folk music were working-class oriented. You can bet they weren't interested in going to the opera or the symphony. I hung out with that gang and then started to write songs. I was writing songs for quite a while when finally I got to Harry Belafonte's music director.

How did that happen?

Well, I was beginning to be known. I hung out at these clubs where they would go around in a circle and I would sing my stuff.

You were nervous about your writing, but suddenly became bold about your songs?

I was beginning to get more confidence. But there were problems even in the folk song clubs. There was this one guy who became a very famous pop song writer later on . . . he'd walk out whenever I would get up to sing. Harry Belafonte's publisher took "Turn Around." That was my first big one. It actually hit the charts and it's been a standard ever since. That gave me an opening.

How old were you when you sold your first song?

Fifty-seven, I think. Of course, nothing happened. I signed a contract and just turned it over to the publishing company. I even let Belafonte put his name on "Turn Around."

He put his name on your song and to this day everyone thinks he wrote it?

Yes, dear. But I was so excited to have him take my song that it was really not important to me whose name went on the label. That song has been good to me because it's been such a producer. Even the small percentage I get means a lot to me. This is true of many songwriters in my position. They're willing to take whatever they can get because it's so much better than what they've had. They don't know the bookkeeping of the music world and the enormous amount of money that records bring in.

The music industry is structured along the same corporate lines as other industries . . . is this true even of folk music?

Don't say folk music to me. I do not wrote folk songs. I write popular songs. I'm *influenced* by folk music.

Okay, you do not consider yourself a folk musician?

No. You see, folk songs are traditional songs. There's a very sharp line. People who write traditional music scorn me.

But the melodies in your music are very folk. . . .

That's true of a lot of popular music. There was a tremendous change in music at the time of the discovery of the folk treasury . . . it's influenced Guthrie and Dylan. . . .

After you sold that song to Belafonte, the Limeliters picked up on your work?

For a while, I had part of a song or a whole song on almost every album they issued. My husband had a heart condition . . . he stopped working as a carpenter . . . we were raising a daughter, so we were really dependent on my income. And I was being fucked over by the Limeliters, also. They would find a folk tune, give it to me to write the lyrics . . . Lou Gottlieb would take the publishing, which was half, and he would take the tune, which

was half of the other half, and I would have a quarter for writing the lyrics. And the worst of it was that he would give me an assignment and I would find out afterwards that he'd also given it to someone else.

Do you think they would have done that to a man?

Well, they did it to me because I was particularly timid. But the fellows get fucked over in the same way. Except they're inclined to be more pushy. I mean, here I am at home all the time, not where everything's happening. . . .

What other business did you have with Lou Gottlieb?

Some of my songs that were recorded by him were picked up by other artists. For instance, one of my kids' songs, "Morning Town Ride," became an international hit. It was picked up by the Seekers and a half-dozen other big-time performers. Of course, even after the song left Lou Gottlieb, he was getting all the publisher's royalties. On the other hand, when Joan Baez recorded "What Have They Done to the Rain," she didn't take anything. She had a very different attitude.

Her politics were more like yours?

Right. So I own "What Have They Done to the Rain." I also own "Little Boxes," which Pete Seeger made a hit out of. He didn't require anything . . . he just used the song.

Have you ever felt competitive? Obviously the music industry has been male-dominated.

Yes, I have felt competitive with other songwriters. I feel like I have something really good that's been shoved into a corner because I can't get through . . . it was years before Wasserman on the *Chronicle* came to a concert of mine.

Do you think it's your politics?

No, I think it's my age. I'm not a slinky pretty one, I'm not, you know, Linda Ronstadt . . . although, when I get in front of an audience, I take 'em over like nothing . . . they love me! But between me and the audience is the manager. There are all these people who have a certain image of a woman performer.

What do you think about women-run music studios and recording companies? Do you work with them?

Well, I have my problems with them but I think they're a great idea. There was Olivia, for instance. We approached them about distributing our albums. But they wouldn't because I had men in the back-up.

That's what they said to Holly Near, about a man she'd been working with for twelve years. And she said if she had to find another musician, it would take her another twelve years to get to know the person!

I was in there fighting a long time before they were born. And they dared . . . it makes me indignant. I had men backing me up because there were no women. Now that there are women, I have women back me.

At one concert you gave, the women requested that all the men leave. You refused to play. How do you handle situations like that?

I'm pretty bossy. They do it the way I want it or forget it. I don't believe in excluding anyone from my concerts except the enemy, or the FBI and you can't get them out anyway. I feel that women have the right to use what they call woman space and not have men in on their energy . . . that's fine. Some women may feel more comfortable without men around, but I will not perform in that situation. Men do not bug me to that extent. I think they

need to be educated. Anyway, those men who come to my concerts are already halfway allies.

Separatism is a problem in other areas of the arts as well. Many of the women's presses are lesbian-oriented and will reject manuscripts by women if the content is what they consider male-identified.

Well, lesbians are finding their strength and sometimes can't see the general struggle. I make a point, when I talk about this, to state that I won't exclude people who are victimized for being revolutionaries. For example, I couldn't exclude my husband, who fought working class battles all his life.

You've had a history of dealing with all kinds of snobbery and exclusiveness and financial abuse. How do you manage?

My business associate, Ruth Burnstein, and I run Schroder Music Company. Ruth does all the hard work. It's a vertical business. I write the songs and the music, we do the recording, we do the books, and we do the distribution.

You operate out of your home. Why do you choose to do it that way?

Because my work is so much a part of my life. It's not an eight to five thing. If I get up at two o'clock in the morning and have a notion to write a couple of lines, I can work it out right here at home.

Was your work ever an interference with your family?

My husband was remarkably supportive. He was in charge of the business when he was alive. He'd sit in the audience and they'd scream for me and he'd beam as if he'd done it himself.
 As far as my daughter was concerned, my career kept me from interfering in her life too much.

You didn't farm out any of the business?

Well, the experience we've had with other outfits has been so unsatisfactory. Ruth and I brought out two songbooks. When we contracted with a small publisher to do the books a while back, they paid me something like $600. They had those two books for years . . . I didn't know enough to give them a cut-off date. Then they sold their company to a big outfit. We had to stand in line behind Elvis Presley and Peter Frampton to get our books printed. Years went by sometimes without our having any reprints. So we said, screw it! We just had to put out our own books.

Isn't that the nasty part of the business, the distribution and promotion?

Not really. Every place I go to sing has my books and records. A book distributing company wouldn't follow up on that so carefully. We do a big mail order business and there are outlets like women's places. So we don't sell a million, but we sell a thousand.

Malvina, you have a terrific sense of humor!

Well, it depends on how you approach things. It's more devastating to give out humor than anger. The irony makes the opposition look ridiculous.

I find myself laughing with your lyrics and then stopping because you're speaking of serious matters.

Yes, it works very well with my audiences. They feel we're all together, having this joke on the opposition.

You applaud your audiences!

I've always done that. And I've become a real genius at involving my audiences. One time I did a concert in Sacramento to a packed house. There were a bunch of kids by the stage, maybe seven or eight years old, sitting there kicking up their feet. When the music started, they stopped kicking and began listening. I'm singing along, about five or six songs into the set and I hear noises. I say, What's the problem? They scream out, We want you to sing "Rosie Jane." Now, do you know that song? I turn to the audience and I say, You will not believe what these kids are asking for. I have to sing it for you so you'll know. . . . (breaks into the chorus of "Rosie Jane")

> Rosie Jane, are you pregnant again?
> Rosie Jane, you can hardly take care
> of the four you had before.
> What in heaven's name were you thinking of!
> Rosie Jane, was it love?
> © Schroder Music Company, 1973

The audience is screaming by this time. I couldn't sing, I was laughing so hard thinking of those kids over there. . . .

Does that astound you that kids know about sex so early?

No, not at all. People bring kids to my concerts thinking, here's this nice little old lady gonna sing folk songs. But even my children's songs aren't cutesy pie. These kids are sophisticated. One of the little girls who was recording with me on one of my albums just came right out and said, All these la-la-las are covering up the words! Eight years old!

You said before that your parents were socialists when you were a child. What were your own political affiliations when you were a young adult?

I was a member of the Communist Party for a long time, but I dropped out in the early 1940s. I couldn't function within the Party because I couldn't sing. It was heavy and dull and hard work. Then came many questionable events, such as the invasion of Czechoslovakia and so on.

When you dropped away from a political body that you closely allied yourself with, didn't that leave you sort of strung out?

It might have except that I was always involved in a lot of political activities. I've been right there with the labor movement, the women's movement, the ecology movement . . . and there was the Progressive Party. At one time, my input consisted of running a mimeograph machine and chairing meetings. Now I just have one function. I'm kind of an auxiliary to every movement I believe in.

Your art comes first?

That isn't quite true. But it's my role in the revolution. I'm not just an artist for myself.

You are one of the few artists who has been able to unite politics and art. It seems difficult. You said earlier that the Party was dull and didn't want you to sing. . . .

Yes, but even now there are problems, because the American movement is not a singing movement. I'm not thinking only of the Party. I'm thinking of American political movements in general. There used to be a lot of singing on picket lines. It's just not done now. There isn't a group joy. My feeling is that the nature of city life keeps us from singing like we would if we lived in tribes or small villages. Or gangs or groups.

There's very little room for song in politics. I wrote a song for Planned Parenthood called "Back Alley Surgery." They loved it but they really didn't know how to use it. If you just extract a

segment of that song or of "Rosie Jane" for radio or TV, in a 30-second spot, all you're doing is sneering at a pregnant woman, which is not the intention of either song.

I wrote a song about nuclear power called "Power Plant Reggae." I sent cassettes all over the country to dozens of anti-nuclear power alliances. I figured that somehow they'd use it. (Breaks into singing, "making steam in a nuclear plant is like killing an ant with a bomb. . . .")

I sent a copy of this song to Barry Commoner. He liked it very much, so I copied his letter and sent it along with the cassettes. Even though I say that there's not a lot of singing done in American political movements, I feel I have contributed what I can to fighting the proliferation of nuclear power. I pay for the cassettes myself . . . I have enough leeway in my income that I can. And with the record I made about the judge in Wisconsin who sanctioned the rape of a high school girl by three boys . . . well Judge Archie Simonson has been replaced by a woman! I financed that record myself.

It sounds like you recycle your earnings right back into the causes you support. You don't compromise your values. Mostly when people become successful, as you have been for a long time, they give up or get slick.

The slick is the bad part.

You never had a desire to go to Hollywood?

Never. Look, if I'd directed my work towards commercial ends, I could have sold many of my songs to other singers. I write good songs. Some of them even become popular by accident! But I just never needed to flash around. I always thought it was more important to do something socially valuable.

Do people actively not want to hear what you have to say?

People are uneasy about the issues I deal with. But I have an ingratiating manner. My stuff isn't hostile. Even when they disagree with me, I'm so good natured about it that they don't get upset. I sang at the Women Against Violence Against Women conference in Los Angeles. There was a great turnout. The only song that didn't get a big hand was called "Song of the Dollies," which is about teenage pregnancy. It's a kind of friendly tune advising young girls that it isn't that much fun to have a baby as a teenager. During the intermission, I was surrounded by a bunch of loving, friendly women telling me why that song was off. . . .

Did they think you were knocking motherhood?

I think they felt the song was condescending or making woman appear as victim. We disagreed, but in such a friendly way. There they were hugging me while telling me their point of view. Of course, Phyllis Schafly wouldn't come to one of my concerts! She knows who I am. But it's not that I just sing for people who agree with me. Whatever, I'm seldom hostile. You know my song "We Don't Need the Men"?

> We don't need the men,
> We don't need the men,
> We don't need to have them round
> Except for now and then.
> They can come to see us
> When they have tickets for the symphony,
> Otherwise they can stay at home
> And play a game of pinochle.
> We don't care about them,
> We can do without them,
> They'll look cute in a bathing suit
> On a billboard in Wisconsin.
> © Schroder Music Company, 1959

I know you don't really feel that way. There's humor in that song, but it could be taken the wrong way.

But you see, nobody takes it seriously. Oh, once a little boy about nine years old came up to me after a concert and said, you don't really mean you don't like boys, do you?

What's the response from men?

Oh, they sometimes boo in fun. I wrote that song in 1956. I read an article that said that married women are not as happy as single women. I wanted to tell the women I knew that they could be perfectly okay without men.

How was the song received in 1956?

Some liked it. It's received about the same now.

How did you know . . . you weren't single in 1956?

Yeah, but I had been. I wasn't married till I was thirty. My mother once said to me, Malvina, you've got brains. Anybody can have babies, but you have brains. For that reason I pushed marriage aside. Oh, I had boyfriends. Then there was the Depression. No job, blacklisted, and suddenly panicked. And I married the wrong guy. That was my first marriage. When I read that little article in the paper about single women being happier I thought, that's me and that's all these women who think they're nobody when they don't have a man. I had a cousin who killed herself by overdosing on reducing pills because she was fat and didn't have a boyfriend. But she was thin in her coffin. Well, I was only married for three years the first time. It was no good.

When were you first blacklisted?

When I left high school. They didn't give me my diploma because I was a socialist. So I was kicking around, trying to work. I was even blacklisted by the telephone company! I kept getting fired. The FBI was after me. They had nothing else to do

but nag at little girls whose fathers were socialists. After college, I'd go for an interview and it'd be very nice. Then they'd go to the placement office for my records. There must have been red tracks all over my files!

You were persecuted all your life but your songs aren't bitter. . . .

I realize it's a class war. I don't blame the capitalists personally. I just think they're a bunch of shitheads. I can get pretty angry but I don't lash out at individuals. Though I can get nasty with FBI agents who get into the movement and become your dear friends.

Do they still sniff around you?

Oh yes. When you called to interview me, I thought, Mmmmm . . . she could be from the FBI, what an easy way to get me to talk about everything. Look, I don't mean it personally.

They must have a dossier on you that's yards wide.

Of course. You know they've sent people into the women's movement to deliberately provoke . . . but you can't stop your work. If it turns out that people are finks, I may have had some impression on them anyway.

Do you feel your political philosophies are more in style now?

It's easier, yes. I can't illustrate anything unless I sing it. (Sings "No Hole in my Head")

> Everybody thinks my head's full of nothin,
> Wants to put his special stuff in,
> Fill the space with candy wrappers,
> Keep out sex and revolution.

But there's no hole in my head. Too bad.

You can do that now without people blinking an eye.

You obviously had your audiences then, but now that everyone's half hippie, your lyrics have more sympathizers than when you started out.

My history is long enough that when the sixties faded out, I never thought that there was no movement left. I've seen ups and downs before. This seems like kind of an up period, though it could get bad.

How do you feel about the sixties? You once said you weren't really interested in bridging the "generation gap" because you've always been with the young people.

I wasn't very involved in the sixties because it was a student movement and I wasn't on campus. The wind blew the tear gas down my street and I'd go out and watch a little. A lot of the activity was very upfront, I felt. But there was a preoccupation with publicity that gave the period a look of importance that I don't think it really had. There wasn't as much of a revolution as there seemed to be.

Wasn't it the closest this country has come to a revolution in two hundred years? Maybe not as it happens in other countries, where people are brutalized en masse. . . .

Well, I wouldn't say it was superficial, just that it was not as heavy as it seemed to be. There was struggle going on . . . like in Chicago. It did help to slow down and stop the Vietnam War. And the black movement had accomplished a good deal.

What would you consider as a more just system of government? Do you see yourself as an anarchist?

No, on the contrary. I believe in people functioning in groups. What is so destructive is that neighborhoods, small tribes, etc. are being destroyed by big systems. No. I'm not an anarchist. I'm a socialist. I know there are a lot of problems in socialist countries. But in the history of Western civilization, socialism as a functioning system is so new, and it's working within a context of surrounding and decaying capitalist worlds. It would be surprising if it functioned well. The Soviet Union has certainly slipped back into bureaucracy. But at least there's no unemployment there. And there are ways for creative people to actually get support. They might be choked off ideologically and that's the bad part. But I think, in the long run, socialism is the way we'll have to go. . . .

Even at the expense of art?

I don't think it has to be at the expense of art. What is absolutely essential is to eliminate private ownership of the means of production and distribution. In my lifetime, it's happened. There were no socialist countries when I was a little girl. Socialism was a dream we were working toward. But now there are large areas of the world that are beginning to function as socialist countries. So I say it looks like progress!

There is evidence of the system breaking down in this country, real resistance, which is essential. Look at these high-rise housing projects. They're being torn to pieces by the people who live in them because the people feel like they're being put in jail to live. These people have not created the environments they're living in and they resent that. Instinctively, they know the housing projects are a mechanical solution to the problem. We need low-rise housing, neighborhoods. . . .

Were you a wild activist in your youth?

I was very well-behaved up to a point, but I was politically active. I hung out at the socialist's school in San Francisco.

When I decided to be sexually free, I cut loose. I wasn't promiscuous, but I went through the back alley abortion thing and the whole bit. Wild? No, not really. I had a good time. I never used any kind of dope. I was a pretty girl and the boys were after me. When I got married, I was a one-man woman.

Do you believe in monogamy?

Well, it's not a thing you believe in . . . the question is whether it's a fact or not.

Maybe it isn't monogamy that's the issue, but the nuclear family.

I think the nuclear family is a blind alley. Originally it was the clan, the extended family. And some people are deliberately moving in that direction again. But mostly, as the nuclear family is breaking up, people are left with no replacement.

I think of families that live in the little boxes of your song . . . but not many of my contemporaries really know how to live differently.

It's changing. I've got a song called "We Can Stop Here," about young people going into the wilderness to live, but of course, that back to nature thing doesn't work either. That's why I feel extended families and neighborhoods are so important.

Do you consider yourself a moral person?

Oh yes. A moral is something that develops over a millennium in order to protect the extended family. It's natural. When you feel moral, you're just a red corpuscle in the body politic and functioning properly. I've done some rotten things in my life and I know it. And that's part of morality, to know what's socially supportive and what's destructive.

Malvina Reynolds 199

How does the artist function in that context? The artist is never exempt from morality and yet can't sacrifice art for the interest of the group.

But individual and artistic values are also inherited. And to inherit something is to take it from a group. You don't just spring up in the forest with no social forebears. A lot of people say they write for themselves, but they are themselves a social audience, an accumulation of social values.

But can you imagine a commune of writers?

No, I can't, that's true. But when people come to me with their songs, I say, go sing to the public, you belong to an audience, you don't belong to me. I'm fighting, myself, to relate to a public. A house full of writers or musicians is nowhere. You make your art for the public, not for other writers or musicians.

Do you associate with other musicians?

Not as much as I'd like, because of my age. I never did what young musicians do, which is hang out in bars or guitar shops and pick up licks. I'm not exactly in a position to hang out with young musicians anymore.

I had a great experience with Dave Bromberg, a fine musician, crazy man, I love his stuff. We met on an airplane going to a festival in Toronto. I gave him my songbook. He said, I'll back 'ya, my band will back 'ya. I was in heaven! When I visited him in his hotel room with my guitar, his men walked out on me. They were hostile. Maybe they thought I was somebody's grandmother. But Dave was so kind. He took my songbook and started playing and said, god, you got some weird chords in here. Well, during the festival we shared the stage for one little piece and then he had to do his show. So I played my set with a woman who couldn't back me very well. Which was too bad, because there was everybody I admired in the music world . . .

John Prine and others . . . and I was doing rotten. I had just said goodbye to my audience when Dave came running up. So I said to the audience, wait, Dave Bromberg is gonna back me on a song. And he did.

Do you have musician friends?

Not primarily. Rosalie Sorrels and I toured together, though we have very different styles.

Is it a problem for you to relate to superstars?

Well, you know, you can't be a solid person when everybody thinks that everything that comes out of your mouth is gold. It warps you. If you get too far above people, your feet are off the ground and you lose your roots and the source of your inspiration and you're stuck up there! In a way, superstars can't help it, because they're cut off from the people by the businessmen who surround them, who want to touch them to get the gold to come off. Not that I was ever in danger of that!

You couldn't have kept your political commitments if you had wanted to put yourself in that danger!

Well lucky for me that my age was against me. I've really been protected from stardom. I had just a little taste when I was recording for Columbia . . . all those people fussing about me.

Imagine a steady diet of that, TV and make-up. . . .

I fight make-up. I won't wear it! It puts a mask on you so you lose your facial expressions, you can't smile and you can't make faces!

Even though you didn't want stardom, were you ever anxious in the beginning about making it?

I had the habit of being shy and putting myself down, but I had a strong feeling about having something good. When the Lime-liters would sing my songs at the Hungry I, which was big stuff in those days, I would be in the audience. They'd ask me to stand up and take a bow once in a while. And all the time they were singing my songs I thought, if I were up there, I'd do better.

It sounds like you put yourself down because you weren't given the credit you deserved.

Mmmmm . . . recently I sang at a coffee house and my then-boss Lou Gottlieb came backstage. He wouldn't let me sing in the old days. And his way of being impressed was to give me advice. He actually advised me to study up on my patterns more and make them 'formal'. He had no idea that one of the big points of my performance is that the audience can see my brain working on the spot. I pause and formulate something to say, or like when those kids came up asking for "Rosie Jane" . . . that became part of my act. I mean, my audience is right there with me, doin' what I'm doin' instead of having something laid on them that comes from the icebox.

Sometimes I write a song and it gets premiered that very night. I saw an article in the newspaper about a mouse that had gotten into the wiring of the central clearing house of a bank and short-circuited the computers. So I wrote a song called "The Little Mouse," inspired by that incident. And two days later, I sang the song at the Great American Music Hall. Everybody in the audience had seen the little newspaper item and here was Malvina Reynolds with a song about it. They were screaming! The immediacy! People are always complaining, Well, you don't sing it the way it's in the book. Well, it's grown! It changes. You have to have the liberty of changing your own songs.

Do you ever go back and change your songs a long time after you've written them?

Yes. I picked up a song the other day and thought to myself, that's got damned good lyrics but the tune is nowhere. My music has improved since I wrote it. So I'm gonna put a new tune to it and use it.

I read a letter in *Progressive Labor* a few years ago from a miner's wife. It almost walked off the page into lyrics. I wrote a song about the letter, but I never sang it. Somehow I felt the song was hers, not mine. That's foolish because I was her voice. I'm like the instrument through which the music goes out to the audience. So now the miner's wife gets part of the royalties. I felt that she had her part in making the song. Just lately, people have begun to ask for that song, since there's been a coal miner's strike. (Sings "Mrs. Clara Sullivan's Letter")

> I'm twenty-six years a miner's wife,
> There's nothing harder than a miner's life.
> But there's no better man than a mining man,
> Couldn't find better in all this land.
> The deal they get is a rotten deal,
> Mountain greens and gravy meal,
> In Perry County.
>
> We live in barns that the rain comes in
> While operators live high as sin,
> Ride Cadillac cars and drink like a fool
> While our kids lack clothes to go to school.
> Sheriff Combs he has it fine,
> He runs the law and owns a mine
> In Perry County.
> © Abigail Music Company 1963

Malvina, I think if you met the angel who inspired you, you'd share your royalties with her. . . .

Well, it didn't amount to a lot. Pete Seeger recorded this song. He did the tune to it. And he gave his royalties to Clara Sullivan too.

I've got to ask you a standard interview question. What kind of plans do you have for the future?

And my standard interview answer is that I'm just gonna keep on doing what I do until I fall down. I like it.

Malvina Reynolds (1900-1978)

Appearances
Newport, Mariposa, National Women's Music and other festivals; university and college campuses; in concert and on television and radio in the U.S., Canada, England, France, Japan, Finland, Sweden; and "Sesame Street"

Film
Subject of the documentary film "Love It Like a Fool," directed by Susan Wengraff, produced by Red Hen Films, 1977

Songs Recorded by:
Pete Seeger, Judy Collins, Joan Baez, Harry Belafonte, Glenn Yarbrough, The Searchers, The Seekers, The Limeliters, Diana Ross, and others in the U.S. and abroad

Albums
Malvina Reynolds Sings the Truth, Columbia, 1968
Artichokes, Pacific Cascade, 1969
Griddle Cakes, Pacific Cascade, 1970
Funnybugs, Pacific Cascade, 1970
Malvina Reynolds, Cassandra, 1970
Malvina, Cassandra, 1972
Malvina—Held Over, Cassandra, 1975
Malvina and Young Friends Sing Magical Songs, Cassandra, 1978

Singles
"The Albatross," Tungsten, 1969
"Little Boxes," Cement Octopus, 1973
"The Judge Said," Young Moon, 1977

Songbooks
Tweedles and Foodles for Young Noodles, Schroder Music
Company, 1961
Little Boxes and Other Handmade Songs, Oak Publications,
1964
The Muse of Parker Street, Oak Publications, 1967
Cheerful Tunes for Lutes and Spoons, Schroder Music Company, 1970
The Malvina Reynolds Songbook, Schroder Music Company,
1974
There's Music in the Air, Schroder Music Company, 1976

Other Publications
Not in Ourselves Nor in Our Stars Either, Schroder Publishing
Company, 1974

Publishing and Recording Companies
Schroder Music (ASCAP), Abigail Music (BMI), Cassandra
Records

Memberships
American Society of Composers, Authors and Publishers;
American Federation of Musicians, Local 6; American Federation of Television and Radio Artists; Phi Beta Kappa; Sierra
Club.

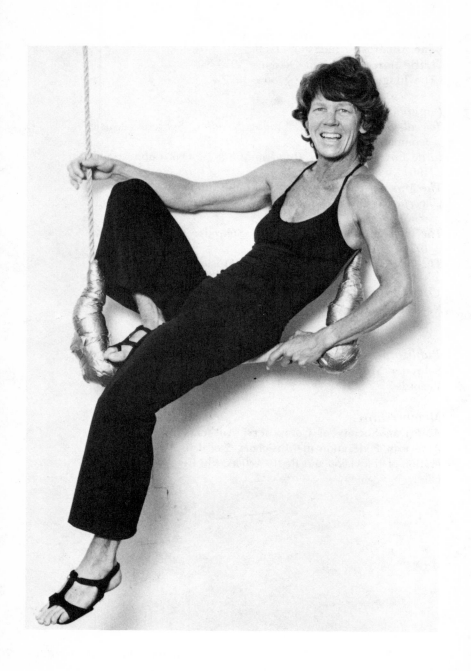

TERRY SENDGRAFF
Dancer

Terry Sendgraff is a former gymnastics coach turned dancer who launched her performance career on the eve of her forty-first birthday. In a defiant reversal of convention, Sendgraff devoted her earlier years to teaching until, as she says, she had to do her own dance. She has developed a unique approach to improvisational movement which she calls "Motivity," a form of theatre that combines elements of modern dance and aerial gymnastics. In addition to an active performance schedule, Sendgraff also directs the Motivity Center in Berkeley, a non-profit performance school. She often collaborates with other dancers, photographers, filmmakers, and musicians, and works with an all-women's performance collective called "Fly By Nite." Born and raised in Florida, Sendgraff took a B.S. in Physical Education and Recreation from Pennsylvania State University, and an M.A. in Dance from the University of Colorado. She has studied with Hanya Holm, Merce Cunningham, Ethel Winter, Anna Halprin, and many other luminaries in dance, theatre, and improvisation.

From a conversation during April, 1979.

Watching you perform, it is difficult to categorize your work. You fly from trapezes and tires, you twist, you spin, you roll on the floor, you dance. You seem to combine improvisational theatre, acrobatics, and movement to make something quite unique. Exactly how do you define your art?

I call it Motivity. It's a combination of dance, gymnastics, and "motional"-emotional improvisation. But that definition doesn't feel quite right to me. Motivity is a process and it's also a method of teaching and learning.

How does it relate to aerial gymnastics?

I used to do aerial gymnastics—trapeze work—when I was twenty-three or twenty-four. It was a little boring; you just fly back and forth, you catch somebody else on another trapeze. It was fun, but a limited form to me. When I started to perform in California, at the age of thirty-five, first I used a swing. I began to use trapezes again shortly before my forty-second birthday performance.

Unlike most people who work in movement and dance, you're quite involved in immediate physical danger with the trapezes.

It isn't so much the height or that the skills I use are inherently dangerous . . . it's the very fact of the equipment and that I never really know about a little piece of hardware with a manufactured fault. Is the rope perfect, how much weight can the ceiling actually take . . . those little things are the unknown, dangerous factors.

You make art within a space of danger. Do you live the rest of your life dangerously?

Sometimes my life is full of danger. I drive a motorcycle. I used to think, oh, it's a death wish. But now I just think I like to do

things that give me a sense of freedom, that involve risk-taking. And I like the state of awareness, the readiness for whatever can happen. I have to be there alert.

Were you always physically active and willing to take risks with your body?

I always liked swings and diving and climbing as a child. I don't remember fear very much. My father was a golf pro and everyone in the family played golf. I hated it myself. I just liked to run on the golf course and do cartwheels.

What were you doing in your twenties?

After college, my first job was teaching dance at a YWCA in Delaware. I had never actually performed as a dancer; it didn't occur to me. I taught to earn a living. Later I knew that dance was something I wanted to study seriously. I began to study dance and gymnastics simultaneously. But they were very separate. I couldn't find anyone that would combine them with any sensitivity.

Did you feel pulled in conflicting directions? It must have been like studying French and German at the same time. The muscles of your body had to move differently for each discipline.

Oh yes. But there was a similar tenseness in dance and gymnastics, which I rebelled against later.

I sampled a ballet class a few years ago and the teacher kept screaming to the students, Your neck, your neck, make your neck longer! Make yourself something you're not. Was that your experience?

Yes. Completely. In gymnastics as well. Both disciplines traditionally want you to look like some perfect ideal. Ballet stresses the aesthetics of movement, not how you *feel* when you're

dancing. Trapeze work is very concerned with tricks. Dance is concerned with a lot of showy tricks too, but dancers don't like to admit that. And gymnasts claim an interest in aesthetics—I question that sense of aesthetics.

When was the first time you actually combined dance and gymnastics?

When I taught at Arizona State University, I was the women's gymnastic coach and an instructor in the dance department. I ended up hating the competition, and the lack of heart in both.

Are there many performers working in some combination between the two?

Well, you see, dance and gymnastics actually have been combined a lot in the history of both. But they remain two separate forms. A cartwheel is gymnastics, a *tour jeté* is dance. I'm talking about merging movements in such a way that they don't have to be categorized so much. I'd rather say I'm moving in a way that feels integrated . . . right-side up, upside down, flying, falling, twisting, turning, and finding equilibrium. People in gymnastics think they're doing it, because they might put ballet into their routine. As I saw it, the dance stuck out sorely . . . you'd do a *tour jeté* and then run and do a cartwheel. It didn't please me aesthetically or kinesthetically. It felt phony to me.

So it was your discontent that made you look for a new form?

Yes. Oh. I liked traditional gymnastics and dance for a while, a long while. It's hard to say exactly why the changes came, but my whole being started to change. While I was doing psychoanalysis in Tucson, I began to let go of that tightness, I began to feel my body and wonder how I would dance if I had my own dance. There's a sort of asexuality about traditional dance and

gymnastics . . . you shave your legs, you pull your hair back tight, you avoid letting go, you avoid feeling, you maintain this tight showy quality in your stature. At some point, I just didn't want that any more.

You also moved away from strict choreography to improvisation. Would you clarify improvisation? The term has a lot of confusing connotations.

Most people think that improvisation means just getting up and doing what you want to do. It's not quite like that. We're improvising now, talking. We improvise all the time. We have certain words in our personal vocabulary that we put together and use. We don't know each other and yet this is the dance we're doing! We're choosing certain words. You haven't really planned this interview, and yet you have certain questions in mind. . . .

One question seems to catalyze the next.

Yes. You see, I have prepared and refined a vocabulary or quality of moving. The infinite combinations of all I know, like the words of a language, I choose and put together . . . so when I'm moving, I've prepared my instrument, my body, I'm aware, I know the possible ways of moving and playing with combinations of movements. When I'm in performance, whatever I select at the time is like whatever I select to say here now. That's where spontaneity comes in, in selective perception.

So improvisation is a spontaneous arrangement, just as a poem might be an arrangement of words?

Yes, in the way that the words come out initially from the heart. I don't think there's any accident in it. There's choice. When I'm performing, I'm aware of what's going on around me, I'm responsive internally and externally, so that if a baby's crying suddenly, that's a reality I can respond to. Spontaneity is being

able to respond to what's going on. If I see someone in the room that I didn't know was there, that changes my emotional state. I can choose to do several things with that. I can choose to be aware of it, rather than to keep on doing what I was doing.

That alertness takes training and control.

You have to scan your own process and the environment's process. You can also make a choice to pick something out and then ignore it. You may not *want* to pay attention. That's different from not having heard it or seen it. That's what I mean by choice, selective perception.

So improvisation is choice?

Yes, out of all the things I know how to do and all the things happening in the environment, I choose spontaneously during a performance. I am interested in the relationship of one movement to another. As in our heads, one thought leads to another. As in relationships, one behavior leads to another. I find the trouble comes when I get stuck in patterns, fixed ways.

Why did you choose to come to the Bay Area?

I liked the lifestyle. There seemed to be a cultural improvisation going on. Anna Halprin was here. She and her husband had written a book about process. And I had been so interested in the process of performance. When I was teaching, I always wondered why everyone was so involved in the goal of the dance. Rehearsals seemed to be a drag most of the time . . . mechanical. Why couldn't dancers enjoy the process? When I read the Halprins' book, I knew I had to go to California. And when I took a vacation here, Anna Halprin had students dancing outside the studio, Lawrence Halprin was doing his architecture while people were living in the building. Constructing a building while people are living in part of it determines the structure,

not the other way around. I was so excited that I went back to Phoenix, quit my job, and moved to California to study.

Was the California you found paved with gold?

Well, after three weeks of studying in Anna Halprin's dancer's workshop, I had to get out. It was intense, and even though she used improvisation, it was still too tight. She was a strong teacher and a strong woman. I needed the freedom for my own search. I didn't want to be directed or taught in the usual sense.

Did you give up studying with other dancers then?

No. I got very confused. I took some modern dance. I didn't know what I wanted and I couldn't find it and I realized I had to find it for myself but I didn't know how! Then I found the most influential teacher of my life, Al Wunder. What he did was give me the opportunity to find my own dance. Which then became the basis of my teaching. I don't teach people to do what I do, I teach them to find out what their own style is. It is a subtle process.

I can see where your interest in process comes from, how you were attracted to improvisation out of a personal need to avoid tedium of rehearsal. . . .

Oh yes. I just do not want to work in a studio all day. I would rather be out in the street gathering what's going on in life and then allowing it to come out in my performance. I have no interest in going over and over the same steps. Not that I don't repeat movements—I just don't put them in a pattern and rehearse them.

Of course, you're speaking as someone who has been working and studying for a while. A novice can't have the luxury of hanging out all day and not practicing.

Once I performed each Sunday in a row for a solid year. I called it "The Year of Sundays," appropriately enough. My attitude is that I'm learning while I'm performing. I'm not going to wait until I have it all together. I did a lot of awful performances during the year, or certainly performances that were not what the usual audience expects. I was fortunate to have a group of followers who were also interested in process. At the end of a year, I felt like I had a real good sense and trust about improvisation.

That's a long span of continuous performing. Even Vida Blue gets a few months off!

It was wonderful. I set up my own limits. A year became a creative problem to solve. There were only a couple of times I didn't want to go. It was my work and my play.

It is play for you, isn't it?

Yes, very much.

Do you work primarily on your own?

I did then, but not now. I'm involved in a performing collective. Another reason why rehearsals are impractical is that all the women in the group I'm currently performing with have jobs. We don't have time for extensive "rehearsals." Of course, none of us are beginners. We've got our vocabulary.

Do you think that collectives and collaborations are replacing traditional ensembles and troupes?

I don't think so, no, not at all. Collectives are just an alternative. Some people need ensembles where there is a certain hierarchy. Collectives are actually different. The basis of a good working collective is people who are developed to a certain level of proficiency, strong individuals who know what they want. I

think it's important to collaborate with a developed individual who knows pretty much who she is. Then working *with* someone else isn't a problem.

How did your collective gather?

Most of the women have studied with me for several years. We've become close; it's like a family. The egos are strong enough so that the individuals can take direction and not feel manipulated. They also give of their own creative expressions.

When you were teaching at the university, did your students frequently become your friends?

Yes. I had always been very friendly with students and was criticized for it. I always felt my students understood the creative process better than the people I taught with. I think my students understood how improvisation blurs the traditional boundaries between life and art. My students like to break the rules to find new ways of expression. It's scary to do that. There's not a lot of support for finding your own ways.

You must have explicit rules working in the group you are with?

Yes, we agree upon things, but out of choice.

Do you have problems being an artist and a teacher at the same time?

No. For me, they're inseparable. Every day I go to teach I think, wow, I get to go teach now! Being able to teach somehow clarifies a lot for me. I put out an idea and I see twelve people using it in the way they want to. I get to watch them create and see what I like, where we can discover and feel comfortable. I like to see new ways of moving and combining familiar ways of moving.

Your students provide models for you?

Right. In fact, I think they taught me Motivity. I knew how I wanted to combine, but I didn't know what it looked like. I knew what it felt like to do a rigid technique but I couldn't see it. Yes, you could say that I learned how to merge dance and gymnastics through teaching.

When did you decide to call your technique Motivity?

After I was raped a few years ago. I made some big decisions then. You see, once you make a decision that you're going to do what you want, you have to keep on it. Because there are a lot of things that influence you to do what you *should* do instead of what you *want* to do. So I asked myself, well what do I *want* to teach? I don't want to teach gymnastics because people come and expect something I don't do. So I decided, I'm going to teach what I want, whether I have two students or twenty students. And I'll call it something different that gives me space to play.

Before you figured out what you wanted, did you wonder what was wrong with you that you couldn't deal with the dictums of traditional gymnastics and dance?

Oh yeah; I'd think, Gee, I don't want to go into the studio and rehearse for hours. What I thought was, I'll just never be a success. So I won't. I don't care. I won't. For a while, I kept thinking, Well, some day, I'll practice every day, I'll force myself. Some day.

When was the first time you launched your performance career doing what you wanted to do?

It was my very first public performance, "On the Eve of My 41st Birthday." I did exactly what I wanted to do. I opened the performance by riding through the door on my motorcycle. I

had fun! It's not as if there wasn't pain that went into it. After all, I went through a lot of self-doubts about performing. This was not what people do, you know, improvisation wasn't all that acceptable. . . .

Was that frightening to you, doing something that not many had done?

Well, people have done it, but *my* sense of doing it was being tested. Emotionally, I didn't have any idea of how my work would be received or how I would feel.

What other fears did you have?

That I wasn't good enough. And who wants to watch an older woman dance?

Are you conscious of your age now?

Yes, but I've let go of thinking of "old." Oh, when I started, when I was thirty-five and I did a few performances in classes and wondered what my own dance was, there was a voice saying, "Nobody wants to watch an older woman dance. You see, when you dance you're supposed to have a certain kind of body, a certain look, a certain face. *You* don't have it."

How did you overcome your own internalized ageism?

Berkeley helped. Gestalt therapy helped. I know we can get a little carried away with the "I'm Okay" syndrome, but I'm talking about it on a really essential level. Acceptance from others helped my own self-acceptance.

Is your teaching your major source of income?

Yes.

Could you make it by performance alone?

Not right now. I could, if that's what I wanted, but you see, I don't want to give up one for the other. I need the exchange between me and my students. When I said that my students taught me Motivity, I meant it. There came a point, because of the nature of what I was teaching, where it wasn't dance and it wasn't gymnastics, and I needed to show people just what it *was*.

So your first public performance actually came out of teaching, in order to demonstrate your movement form?

Yes . . . in order to attract students to what I was doing. As a gymnastics teacher I had a very different kind of person coming to my classes.

What was the difference?

The gymnastics person is goal-oriented. She would come to me saying, I wanna learn these tricks, I wanna learn a back flip, I wanna learn cartwheels, it doesn't matter what I feel like, I want you to whip me into shape. Tell me what to do. I don't want to be an authority figure. I am, in a sense, anyway, just by being a teacher, and I do give direction, but there has to be a whole lot of space in the directions for choices.

It sounds like you're giving your students what you wanted from your teachers.

Yeah. And I think that's what creativity is. Solving your own problems, in your own way. I couldn't fit into the other way and I was very frustrated. I didn't like feeling there was something wrong with me. So I created something else.

There's a big leap between feeling frustrated and being able to make things different.

It really does have to do with self-acceptance. There must be some way to teach it, so that you can learn to do what's right for you in spite of those around you saying, or you saying to yourself, Well, that's not the norm. And it isn't just you saying I'm okay and the hell with everything else. It's I'm okay and I see my relationship to other people and my environment. In accepting myself, I expand.

You don't feel isolated?

No, I don't. It's one of the advantages of performance. I have a need for more isolation. I have to choreograph time to get off by myself. Sometimes I feel lonely. Isolated, no. As an artist, I don't know what that is.

A newspaper review of your work referred to you as a radical lesbian feminist. What does that mean and how does it relate to your work?

I'm not sure I used that term. Those titles are weird for me. I think it's important to live according to your own lights, instead of allowing the external world to tell you what the issues are and how you should respond to them. It just so happens that I discovered that the basic ways of living are what I consider feminist . . . in my teaching for example. My methods are opposite from authoritarian teaching. And the personal art form I believe in is the antithesis of traditional theatre and dance . . .

Do you feel you're feminizing performance?

Well, yes. But you know, it's so integrated for me that I feel I need to check out why the term authoritarian is connected to male ways. Why is rigid discipline associated with the male way of teaching? What do I mean by that? What do I mean when I say I'm a feminist?

Is it approach, rather than rhetoric?

I feel strongly about that. It's the way you do things, not what you say about them. I work with five strong women. Four of us are lesbians, one of us isn't. And that's who we are. We're doing what's true to ourselves, which ends up being very feminist. If we're not smiling, then that's okay. It's honest and somehow honesty is a part of feminism to me, rather than the standard "the-show-must-go-on" approach, stiff-upper-lip and don't-show-what-you're-feeling attitude.

Do you feel competitive with the women you work with? Do you experience egos clashing?

Ego. There's a lot of put-down about ego in a time of awareness rhetoric and Eastern mysticism. But wait a minute, what are we talking about? Each of us has an ego and there's such a big emphasis on getting rid of it. I think that's a mistake. My ego has a good function as an artist or otherwise. I know who I am because I have an ego. It clarifies who I am before I can disappear into enlightenment! I want to know what my ego does. I'm going to give it full attention. When I'm feeling that I'm not getting attention or when I want more, I don't want to hold my ego in. That's energy I need. I want to be able to tell you I need more attention. And that's where my ego comes in real handy. When I get the attention I want, it will serve me and serve others in a positive way.

What about jealousy?

Okay. Say I'm jealous of a friend. If I have to hold it in, it comes out in all kinds of insidious ways. If she's jealous of me and doesn't say it, that's where the clashing of egos comes in. The weakness of an ego tells me where I'm weak, so I can build! My ego can tell me how I can get more attention without hitting somebody over the head for it, or without undercutting somebody else. So "I need to do a solo," "I feel lost in the group," that's my ego need. For a while, I may need attention, just simply attention.

From your perspective then, the ego is a signaling device, not so much a defense barrier?

Yes. Those defenses are what we're used to living with—for example, defending the need for attention. It's the unsatisfied ego that goes hungry and gets us into trouble.

Performing artists are famous for having "big egos," needing a lot of attention. . . .

Listen, we all need attention. If we could give each other more attention on a basic listening level, we wouldn't go around needing it so badly! Artists have, in fact, a remarkable amount of ego strength to do what they do. They're willing to ask for attention. They're willing to say, I'm doing a performance, come and pay to see me. I find that the more attention I get, the less I need. I know more of who I am now because I admitted I needed attention and I got it in a positive way.

As opposed to when?

When I was in college, when I was not performing, when I was just teaching. If someone came to observe me teach, I'd worry about what they thought of me. I spent a lot of time worrying about what people would say. And so I didn't do a lot of things. I was afraid a lot.

What are some of your greatest stumbling blocks in your art, things that cause you difficulty or deter your progress?

Strangely enough, the ego . . . the defensiveness of the under-developed, damaged, or unaccepted ego.

Yours or other people's?

Both. And the unwillingness to admit shortcomings, negative thoughts, the dark side. Unwillingness to express those parts of

myself that are not so pleasing. After all, I'd like to please everyone, therefore I must only show the best side of myself.

Is that left over from your dance training?

Yes, and my childhood and educational experiences in general. And I think it's much more far-reaching in our culture. That certain emotions are even called negative is a sign that most people want to ignore them. But you know, emotions are energy. My big stumbling block is having to withhold part of myself and worry what others will think. That's withholding energy. I'm really my own stumbling block. I really feel very responsible for what happens to me, my relationships, my money.

Did you always feel that way?

No. I used to think it was all done to me. Or, that's the way it is. But I've come to see how I set things up. I had to set up my classes, I had to set up my performing. I had to make things work. A friend of mine went to New York because he said he couldn't perform here. I said, wait a minute, I set up The Year of Sundays because I wanted to perform more.

Learning to believe in their own efficacy seems to be a big problem for many women.

Well, it is if you try to solve all the problems at once. For example, you want to perform more and make more money at it. That's somewhat unrealistic. I had to solve my money problems in another way, the teaching. The issue is what you want. You want money? Then go work at that job. If you want to do what you want, then be willing to sacrifice the money, for a while anyway. Of course, I know I'm privileged because I can see that I have choices. This attitude is questionable to some people.

Some people don't have the opportunity to even learn this attitude. But I've also worked very hard to be able to earn a living the way I want to.

Do you have trouble promoting yourself as an artist?

Yes, I always have. But it depends on how badly you want to get your work out. Promoting yourself is learning how to express what you have to say. If you go out to promote yourself with the fear that you're imposing upon someone, then you're assuming responsibility for the other person. You have to be willing to be rejected and that's the fear and the risk. If your heart is beating and you want to see somebody, you will. So why shouldn't you put yourself out with your work? You have to keep your eye on what you want. If you don't, you'll be floundering around out there. That's what promoting yourself is, taking full responsibility for your work.

Your work demands a lot from your body. Dancers and athletes can't perform forever. How do you deal with the thought of your body going slack on you?

Well, you see, I'm not dancing the other way any more. I don't do something you have to do twenty of each day in order to maintain. I think I am blessed with a strength and a power. I don't do the big tricks, the aerial cartwheels or the back hand-springs, any more, because I don't want to put in the kind of energy it takes to maintain those tricks. If I couldn't move and I still wanted to perform, I would sing. And I wouldn't wait until I'd learned all about singing before I sang. I want to do what I want to do *now*. I have no use for heaven. And when I get so out of it that I can't do the simplest thing I know how to do, I'll just get on stage and sit there. I'm not afraid to do that.

Terry Sendgraff 223

Do you have doubts?

I think that doubt rides along on my shoulders. But you know, if I couldn't perform again, I've done it. Everything now is icing on the cake. Oh, dear. I just felt a lot of doubt for a minute.

Terry Sendgraff (b. 1934)

Major Performances
1974-1979 "Everyman's WonderWoman," a dance-theater-film piece in collaboration with Al Wunder and Phil MacKenna
1974 "On the Eve of My 41st Birthday"
1975-1975 "The Simple Art of Eating," an awareness dinner-dance performance in collaboration with Al Wunder and musician Jim Nollman, performed two years semi-annually at Thanksgiving and spring solstice, produced by The Theater of the Ordinary
1975 "On the Eve of My 42nd Birthday"
1976 "On the Eve of My 43rd Birthday"
1976 "A Month of Sundays" a series of Sunday evening solo performances
1976 "Suppertime," a series of Sunday evening solo performances
July 1976 through July 1977 "A Year of Sundays," a year-long series of fifty-two consecutive performances of solos and collaborations
1977 "44th Birthday"
1978 "45th Birthday"
1978 "Fly By Nite": A Motivity Score for Nine Performers Specializing in Aerial Dancing

Debra Heimerdinger lives in San Francisco, where she is a photographic consultant specializing in portraiture and documentation. She has worked on several photography projects funded by the California Arts Council and continues to work for the East Bay Community Arts Project teaching a Photo/Writing class for juvenile offenders. Recently, she co-authored, with Naomi Weissman, *Self-Exposures: A Workbook in Photographic Self-Portraiture* (Harper & Row). She was born in Brockton, Massachusetts in 1942.

Diana Coleman was born in Brooklyn, New York in 1944. She was art director for *Ramparts* magazine and did the illustrations for *Recipes for a Small Planet* (Ballantine). She lives in Oakland, California and works as a freelance photographer and graphic designer.

Gloria Frym is a poet currently living in Oakland, California. Born in Brooklyn, New York in 1947, she grew up in Los Angeles and lived in Albuquerque, where she took a B.A. and an M.A. from the University of New Mexico. She has worked as a technical writer and editor, a researcher in bilingual education, and a teacher of high school and college English. Her first book of poetry, *Impossible Affection*, was published by Christopher's Books in Santa Barbara. She is a contributing editor to the *San Francisco Review of Books*.